LEGENDARY LOCALS
— OF —
# HILTON HEAD
SOUTH CAROLINA

BARBARA MULLER
FOR THE HERITAGE LIBRARY FOUNDATION

Copyright © 2013 by Barbara Muller
ISBN 978-1-4671-0046-5

Legendary Locals is an imprint of Arcadia Publishing
Charleston, South Carolina

Printed in the United States of America

Library of Congress Control Number: 2012946904

For all general information, please contact Arcadia Publishing:
Telephone 843-853-2070
Fax 843-853-0044
E-mail sales@arcadiapublishing.com
For customer service and orders:
Toll-Free 1-888-313-2665

Visit us on the Internet at www.arcadiapublishing.com

**Dedication**
*This book is dedicated to Bill and Gwen Altstaetter for their devotion to the preservation of history and to my husband, Al Muller, for his loving support.*

**On the Cover:** From left to right:
(TOP ROW) Ormsby Mitchel, Union general (Library of Congress; see page 32), Harriet Tubman, abolitionist (Library of Congress, see page 30), Gaspard II de Coligny, early colonist (Wikipedia; see page 12), Clara Barton, Red Cross founder (Library of Congress; see page 41), Alfred Loomis, physicist (Library of Congress; see page 46).
(MIDDLE ROW) Charles Fraser, developer (Fraser family; see page 66), Henry Dreissen, civic leader (Palmetto Electric; see page 70), Angus Cotton, hotel manager (Cotton family; see page 54), Willis and Doris Shay, arts and cultural leaders (Shay family; see page 86), Fred Hack, developer (Hack family; see page 50).
(BOTTOM ROW) Isaac Stevens, Union general (Library of Congress; see page 29), Martha Baumberger, early mayor (Baumberger family; see page 59), Ben Racusin, first mayor (*Island Packet*; see page 57), Peggy Pickett, history reenactor (Peggy Pickett; see page 20), David Hunter, Union general (Library of Congress; see page 30).

# HILTON HEAD
## SOUTH CAROLINA

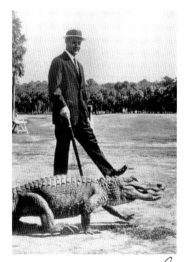

*A man and his pet on HHI.*
*We enjoyed our stay*
*Jessica + Bob*
*2/2015*

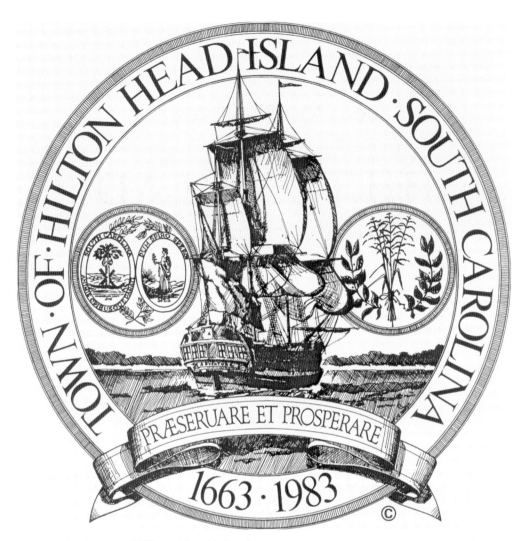

**Seal of the Town of Hilton Head Island**
Hilton Head's seal incorporates, in the left circle, the seal of the State of South Carolina with the state's mottoes, *Animis Opibusque Parati*, "Ready in Soul and Resource," and *Dum Spiro Spero*, "While I Breathe I Hope." The town's motto, *Praeseruare et Prosperare*, "Preserve and Prosper," is also across the seal at the bottom. (Town of Hilton Head Island.)

**Page 1: Hilton Head, a Tale of Planned Development**
When Charles Fraser began developing Hilton Head Island into a model planned community, this photograph of him walking with an alligator nearby became iconic; today, a sculpture of Charles and the alligator is located in Compass Rose Park. (See page 66 for more information.) (Fraser family.)

# CONTENTS

| | |
|---|---|
| Acknowledgments | 6 |
| Introduction | 7 |
| CHAPTER ONE   In the Beginning | 9 |
| CHAPTER TWO   The Start of Settlement | 15 |
| CHAPTER THREE   Prospering Settlers | 19 |
| CHAPTER FOUR   The Civil War | 25 |
| CHAPTER FIVE   The Long Quiet | 37 |
| CHAPTER SIX   Bringing the Necessities | 47 |
| CHAPTER SEVEN   A Philosophy of Development | 65 |
| CHAPTER EIGHT   Building the Good Life | 77 |
| CHAPTER NINE   Giving Back | 111 |
| Bibliography | 125 |
| Index | 126 |

# ACKNOWLEDGMENTS

I would like to thank the following people and organizations: David Ames, Linda Behling, John Brackett Photography, Timothy Burke, Bobbe Carota, Bob Ciehanski, Chris Clayton, Beverly Cotton, Wilbur Cross, David Curry, Gloria Daley, Davis family, Greg Deloach, Ruth Edwards, Dodi Eschenbach, Fraser family, Margaret Greer, Frederick Hack, Norman Harberger, Natalie Hefter, Hilton Head Dance Theater, *Hilton Head Monthly*, Barbara Hudson, Tonya Hudson, *Island Packet*, David Jones, Barry Kaufman, Beryl Lamotte, David Lauderdale, Bob Little, Drew Martin, Lois Masteller, Phyllis Mauney, Don Mcloud, Sara Lee Murphy, Robert Onorato, Beth Patton, Don Peterson, Vicki Pfannenschmidt, Peggy Pickett, *Pink Magazine*, Tom Reilley, Leslie Richardson, Willis Shay, Faidra Smith, Stan Smith, and John Witherspoon.

# INTRODUCTION

*Glooms of the live-oaks, beautiful-braided and woven*
*With intricate shades of the vines that myriad-cloven*
*Clamber the forks of the multiform boughs*

—Sidney Lanier, "The Marshes of Glynn"

When I started this book, I already knew that the semitropical island of Hilton Head was a romantic place. How could it not be, so graced with the live oaks that enchanted the Georgia poet Sydney Lanier, draped with blue-green Spanish moss and surrounded by palmettos and palms? Had there not been Southern belles romanced on colonnaded verandas here by gallant, handsome Confederate officers before they marched off to support what would become known as the Lost Cause?

Then, I discovered there was modern romance here, too, in the stories of the Greers (see page 96), the Carotas (see page 121), and the Shays (see page 103). But I soon realized that there was far more here than romance.

Immersed in history, I already knew about the early attempts by European powers to found settlements here (see page 11) and about the invasion of Hilton Head Island by the Union in 1861, the latter being well documented (see page 25). But I was to find out that there is more to our history than the documents.

There was a great silent period in the last part of the 19th century. Until the first bridge was built in 1956, the island was isolated. Amid this isolation, the Gullah culture flourished and was lovingly preserved by those who had been freed—and their descendants. Here, they built a simple, self-sufficient, and mutually supportive way of life (see page 37).

Since coming to Hilton Head Island, I've heard many stories about the legendary "Fraser years." Charles Fraser, inspired by studies of resort planning and by such writers as Sidney Lanier, had a vision. He also had a knack for finding people who shared his vision; together, they created a new paradigm for resort building that was designed to preserve the flora, the fauna, and the natural beauty of this place. Fraser's philosophy was to become the inspiration for countless such projects.

But until I talked to some of the people who were inspired by Charles Fraser, I did not really know what a communal effort it was. Just as the Gullah people had relied on each other a century earlier, so the people caught up in Fraser's vision joined hands to help make the island what it is today. Person after person told me what a "give-back" community they found on Hilton Head Island.

Charles Fraser's brother, Joe Fraser, was largely responsible for another island institution, the Heritage Classic, where some of the nation's greatest golfers compete.

So these two streams—the native Gullah population and the ecologically minded developers—are here intertwined.

They discovered unity of purpose when the island's unique beauty and the Gullah way of life were both threatened when a chemical company announced it would install a huge plant just across the water from Hilton Head Island, discharging tons of effluent into a pristine estuary. You will see that story on page 84.

In these pages, I have shared only a fraction of these stories and introduced only a few of the people who were—and are—legends in their own time. There are many more whose well-deserved recognition will surely come in time.

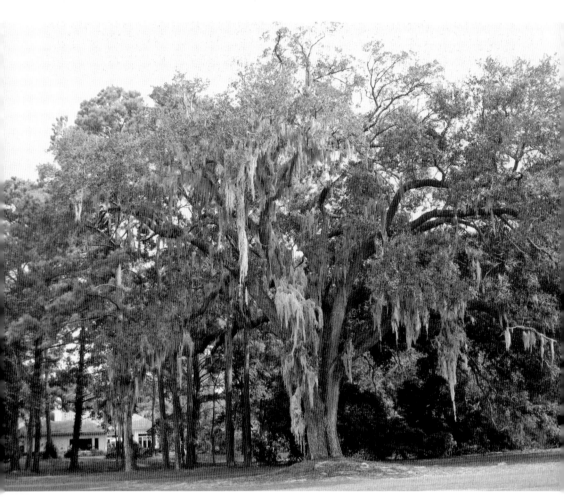

**Live Oaks**
Emblematic of the Lowcountry and of Hilton Head, the stately live oak hung with Spanish moss is ubiquitous on the island. This one is behind the author's home. (Author's collection.)

# CHAPTER ONE

# In the Beginning

*If you could have visited Hilton Head 25,000 years ago,
the foliage and trees would have resembled those . . . of Maine.*

—Margaret Greer

The land that was to become Hilton Head Island was once about 300 miles from the sea to the east. When the ice began to melt, the seas rose and moved westward, and the formation of the Sea Islands began. Ten thousand years ago, Hilton Head was very nearly its present shape, though the sea continued to pound and shape it.

## Charles V's Holy Roman Empire to Include Hilton Head

He was Charles V of the Holy Roman Empire and Charles I of Spain (1500–1558), and he wanted some of that newly discovered land that lay to the west. He gave a grant that covered all of the present-day Carolinas to Lucas Vasquez de Ayllon, a Spanish New World official then living in Santo Domingo. De Ayllon, who shared his king's thirst for new land, assembled 600 settlers and a number of ships and horses in 1525 and set sail for what is today Port Royal Sound, the body of water just off Hilton Head. According to Virginia C. Holmgren, after a short stay in the area, "not finding it to his liking, he sailed on." Accounts differ as to where he settled, but his group would not remain long. Many sickened and died, including de Ayllon, and when the colony had dwindled to 150 discouraged settlers, they pulled up stakes and sailed back to the Indies. (Painting by Bernard van Orley, c. 1515, in the Louvre.)

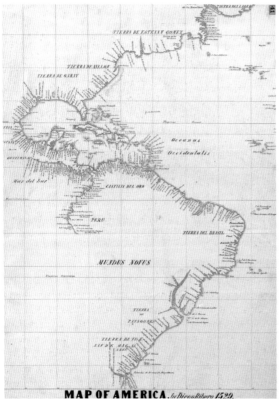

## Tierra de Ayllon, an early name for Hilton Head

The first time the Hilton Head area appeared on a map, it was labeled "S[anta] Elena" in Tierra De Ayllon. This is a detail from the 1529 world map by Portuguese cartographer Diego Ribero. After the death of Charles V, Spain lost interest in the area, finding Mexico and Peru to be much more lucrative. De Ayllon's memory lingers on Hilton Head in place names and the nimble Marsh Tacky horses (see page 40), descendants of the horses those first settlers left. (Library of Congress.)

**Peter Martyr d'Anghiera (1457–1526)**
It is thanks to Peter Martyr d'Anghiera, the chronicler in the court of King Ferdinand and Queen Isabella, that any of Hilton Head's early history is known. The expedition sent by de Ayllon had captured and brought back several Native Americans in 1521. One of the Native Americans learned Spanish and was baptized as Francisco de Chicora, since he had said his land was named Chicora. Francisco must have enjoyed himself with Martyr, telling him fantastic tales of the New World, such as claiming there was a race of people here whose tails were so large that their chairs required holes to accommodate them. When de Ayllon made his own trip to the Carolinas, Francisco came with him but then slipped off to rejoin his people. (From an 1825 engraving by Henry Meyer, published by L.B. Seeley & Son, 169 Fleet Street, November 1825.)

LEGENDARY LOCALS

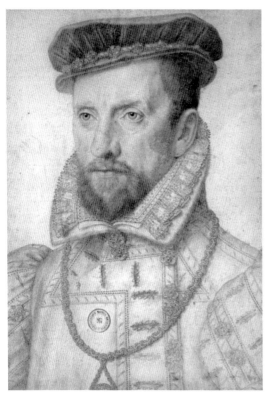

**Gaspard de Coligny (1529–1575)**
Gaspard de Coligny was a leader of the Huguenots of France, a group following the theology of John Calvin. Persecuted in France, many of the Huguenots fled to the New World. Coligny financed an expedition to the Hilton Head area to escape French persecution, led by Jean Ribault (also spelled Ribaut). Although that settlement did not last, many Huguenots later fled to the Carolinas, and Ribault's landing is celebrated annually. Their descendants formed the Huguenot Society of South Carolina; a number of them can be found on Hilton Head. A street on Hilton Head Island is named Coligny Circle in honor of Gaspard de Coligny; next to it is Coligny Plaza. (Wikipedia.)

**Henry Laurens**
Huguenot descendants in the area became numerous, among them Henry Laurens (1724–1792), a wealthy rice planter who represented South Carolina at the Continental Congress. He succeeded John Hancock as president of the congress and signed the Articles of Confederation on behalf of South Carolina. Henry's son John, a colonel on Washington's staff, believed that Americans could not fight for their own freedom while simultaneously owning slaves and persuaded the Continental Congress to authorize the recruitment of a brigade of slaves who would be given their freedom after the war. However, when John presented the plan to the South Carolina Provincial Congress, it was overwhelmingly rejected. (Library of Congress.)

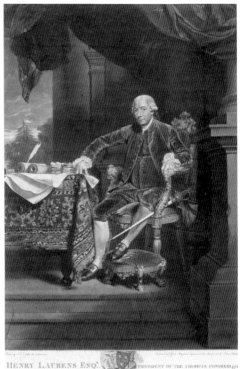

CHAPTER ONE: IN THE BEGINNING

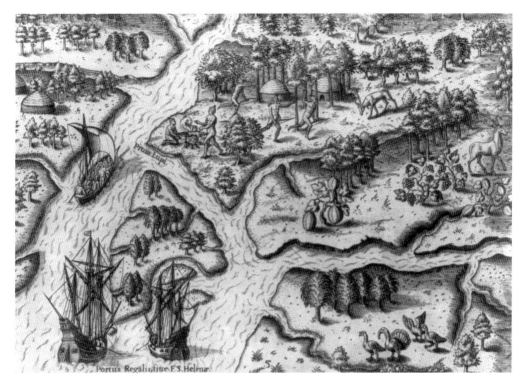

**Jean Ribault (1520–1565) Looms Large in Hilton Head Memory**
Historical groups regularly commemorate the French explorer Jean Ribault, who claimed this land for his king by erecting a marker. The marker's exact location has never been determined, though it is believed to be in the Hilton Head area. Its existence is known from Theodore deBry's engravings, which were based on watercolors by Jacques LeMoyne, who accompanied Ribault. The bottom one is of an Indian chief showing René Laudonniere, captain of the expedition, the marker; the top one is supposed to show the area now known as Port Royal Sound, the body of water next to Hilton Head. Note the turkey. (Both, Library of Congress.)

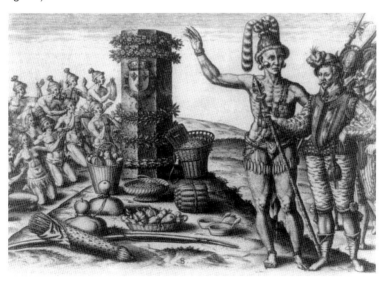

**Capt. William Hilton's Ship *Adventure***
By the time Capt. William Hilton spotted the bluff he named Hilton Head in 1663, the local Indians had settled down into a more agrarian lifestyle, raising corn, pumpkins, watermelons, and muskmelons, but they were still hunting deer. According to Hilton, the rivers were full of every kind of fish, and on land were to be found every type of fowl, including geese, swans, turkeys, and ducks. The report that he sent back was turned into a sales brochure to entice settlers, but it would be many years before anyone settled on Hilton Head itself. The painting *Adventure*, as imagined by Hilton Head artist Walter Greer, hangs in the Coastal Discovery Museum in Hilton Head. (Heritage Library.)

# CHAPTER TWO

# The Start of Settlement

*[A]lthough fear of the Indians and Spaniards long kept settlers away . . . the land . . . was eventually claimed. [I]t was excellent farming land and the Proprietors had especially urged the settlers to plant crops "to satisfy ye belly . . . as ye foundation of yr Plantation."*

—Virginia C. Holmgren, *Hilton Head: A Sea Island Chronicle*

Crowned heads in Europe had tried in the 16th century, without success, to found permanent settlements in what are today the Carolinas, but it was not until the English laid claim to the area that permanent settlements began in Hilton Head. From 1670, when William Sayle arrived from the Bahamas as the first governor appointed by King Charles II, until the American Revolution, Carolinians prospered, raising rice, indigo, and cotton. Some owners of plantations on Hilton Head Island lived in nearby Beaufort, often with second homes on the island. In time, the plantations covered the entire island. Maps of the early plantations are available at the Heritage Library.

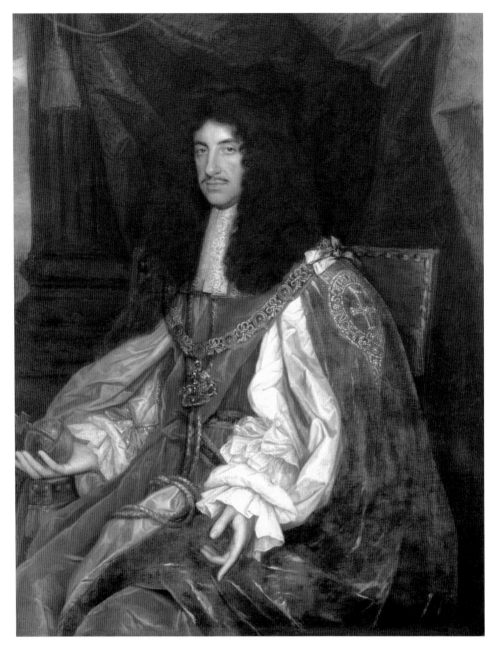

**Charles II of England in the Robes of the Order of the Garter**
In March 1662, Charles II of England (1630–1685) granted a huge slice of land in what was to be called Carolina to eight Lords Proprietors, likely a reward for their help in restoring him to the throne. They were the Earl of Clarendon, the Duke of Albemarle, Lord Craven, Lord Berkeley, Lord Ashley, Sir George Carteret, Sir William Berkeley, and Sir John Colleton. It seems that Charles II probably had his own financial interest in Hilton Head—the next year he sent William Hilton, then in Barbados, to explore the area for possible settlement for the Barbadians. They needed land to grow food since their own land was devoted almost entirely to sugarcane crops. (Portrait by John Michael Wright or his studio, National Portrait Gallery, London.)

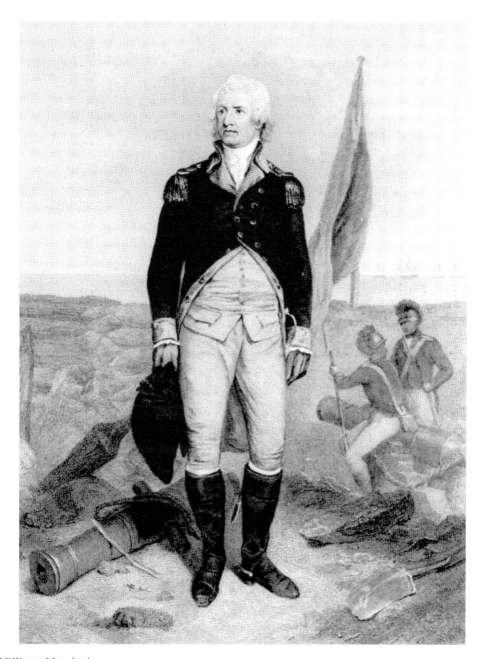

**William Moultrie**
During the Revolutionary War, the planters of Hilton Head favored the Patriots, while planters in nearby Daufuskie Island were Tories, loyal to the Crown. Port Royal Sound, off the north end of Hilton Head, was a highly desirable entry to the whole area, and the British thought to take it. In what was to become known as the first Battle of Port Royal, William Moultrie defended Port Royal against the British in 1779. The Americans outnumbered the British but were disadvantaged by having to fight in the open against the British, who had cover in the woods. It was a brief skirmish won by the Americans and was said to have been a boost to the morale of the Patriots. Later, Moultrie was to serve two terms as governor of South Carolina. (Painting by Alonzo Chappel, National Archives.)

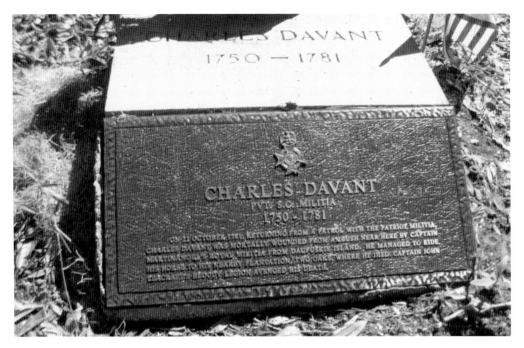

**Charles Davant, Murdered by British Loyalist**
An especially bloody episode of the Revolution is recalled by a marker in this cemetery. Charles Davant, a Patriot, was returning to his home one chilly December morning after spending the night watching for British Loyalists from nearby Daufuskie Island. He had almost reached his plantation home of Two Oaks when he was fatally shot by a man he recognized, Captain Martinangel of Daufuskie. His death precipitated a horrifying revenge as a large group of Hilton Head Patriots went to Daufuskie, killed Martinangel, and plundered his home of all his possessions. (Author's collection.)

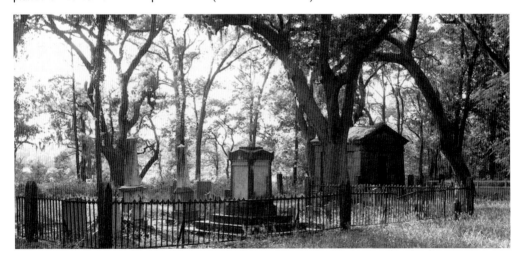

**Here Lie Patriots of the American Revolution**
The cemetery is all that remains the Zion Chapel of Ease, which was built in 1833 for the convenience of Hilton Head islanders. Among those interred are many of the Patriots and planters of the island, among them Isaac Baldwin, William Baynard, seven members of the Davant family, and 12 members of the Kirk family. (Heritage Library.)

# CHAPTER THREE

# Prospering Settlers

*[After the Mexican War of 1848] Hilton Head boys went off to college in the north or in England, took the Grand Tour of Europe and came home to read their books and pursue their favorite hobbies of hunting and fishing. Their sisters went traveling also, and bought gowns in Paris, bonnets in London, musical instruments in Italy and frills and trinkets wherever fancy took them.*

—Virginia C. Holmgren, *Hilton Head: A Sea Island Chronicle*

South Carolina settlers began to grow wealthy on indigo (including some grown on Hilton Head Island) thanks to a teenager named Eliza Pinckney. It was cotton, especially the long-staple variety known as Sea Island cotton, that brought real prosperity to Hilton Head Island. Myrtle Bank Plantation, where the first large crop of Sea Island cotton was grown, is today mostly under water. At low tide, the ruins of the foundation of the big house are visible.

### Eliza Pinckney

Eliza Pinckney was one of those Barbadians who settled in South Carolina. She was only 16 when she had to take over management of the family plantations. An accomplished botanist who had studied in England, Eliza was to experiment with a number of crops to see what would grow best in the area. She developed a strain of indigo and shared the seeds with other planters, and planters from Charleston to Hilton Head all grew rich selling indigo to England. Two of Eliza's sons were among the founding fathers of the United States, and Pinckneys are still active on Hilton Head Island. (Gibbes Museum of Art.)

### Peggy Pickett

Peggy Pickett, a volunteer at the Heritage Library and an experienced living history interpreter, portrays Eliza Lucas Pinckney. Now a resident of Hilton Head, she spent many years as an interpreter for Colonial Williamsburg. Her presentation of Eliza Pinckney is thoroughly researched and much in demand. (Peggy Pickett.)

## CHAPTER THREE: PROSPERING SETTLERS

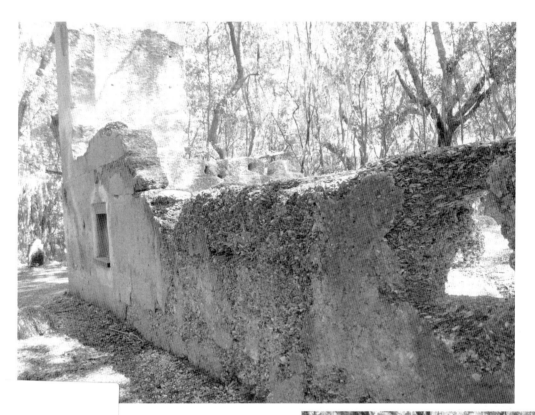

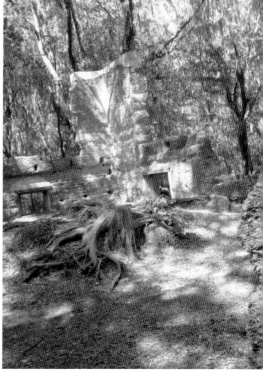

originally belonged to John
great deal of money in the
by freebooting on his ship *Saucy*
tates that John Stoney's son John
ost this mansion to local planter
high-stakes poker game. However,
Lyman Wooster, a Heritage Library volunteer who
writes often on local history, says, "It is more likely that
Baynard purchased the 1,000-acre plantation from the
Charleston bank for $10,000 in 1840." Under Baynard's
management, the plantation became quite prosperous,
but William died in 1849, four years after having the
Baynard Mausoleum built (see the next page).

Ephraim Baynard inherited the property but left
in 1861 when the Union invaded. The mansion
was occupied for a time by Union soldiers but was
subsequently burned—some say by the Confederates.
After the war, the Baynards reclaimed the property
but never rebuilt. The ruins stand as a mute testament
to the rise and fall of "Saucy Jack" Stoney and the
more careful stewardship of William Baynard. (Above,
author's collection; right, Heritage Library.)

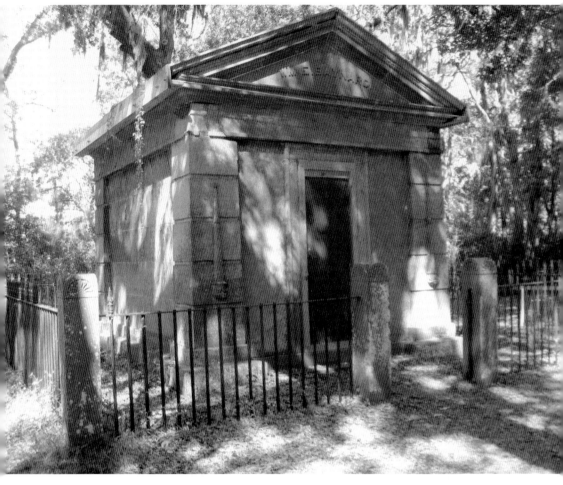

**Baynard Mausoleum**
One of the island's most famous ghost stories involves the 1846 Baynard Mausoleum. It is said that the spirit of William Baynard can be seen mourning the death of his first wife, Catherine Baynard (née Scott), with her hearse, drawn by four black horses. The ghostly funeral procession approaches the mausoleum and then disappears. Night watchmen, guarding some materials during the island's development, were said to have shot at it and refused any night duty thereafter. The mausoleum is the oldest extant structure on Hilton Head Island and is in need of considerable repair. The mausoleum originally had carved marble doors, but according to some reports, soldiers during World War II vandalized the building. Not finding the expected treasures, the vandals threw the caskets into the marshes of the Broad River. It has been reported that the remains of the Baynards were decently interred elsewhere. Recent repairs stabilized the roof of marble slabs, but the center beam needs replacing. (Author's collection.)

### The Roots of Gullah Culture and History

Throughout the Sea Islands, including Hilton Head, people from Africa, especially West Africa, were brought in chains to the South Carolina coast and were sold to grow rice and cotton on plantations. Broadsides like this (left) advertised their availability; this group included a cook, a carpenter, field hands, and even infants and children. They were typically housed in cabins such as these (below) on the Drayton Plantation on Hilton Head. Louis de Saussure was a trader in slaves and provided many of them to Sea Island plantations. (Both, Library of Congress.)

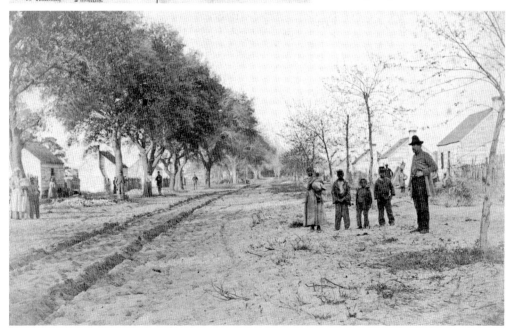

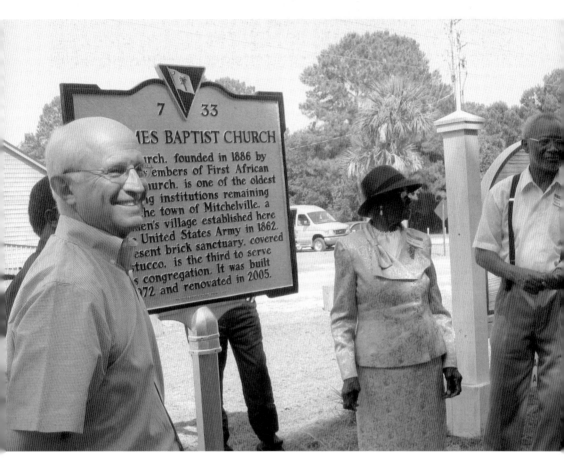

**Mayor Drew Laughlin Unveils a Marker**
Remembering a past when slaves toiled on Hilton Head, members of St. James Baptist Church, many of them descendants of slaves, erected a marker commemorating the church's past in 2012. Mayor Laughlin, who unveiled the marker, has practiced law on the island since 1977 and was elected to a four-year term as mayor in 2010. Also attending were Mother Ethel Rivers (center) and Deacon Henry Driessen (right). (Author's collection.)

# CHAPTER FOUR

# The Civil War

*Blacker than any September hurricane sky were the war clouds of April, 1861. South Carolina had seceded the previous December, the first state to do so, and signing the Ordinance of Secession for Beaufort District was Richard James Davant, who had been born on Hilton Head in 1805.*

—Virginia C. Holmgren, *Hilton Head: A Sea Island Chronicle*

The Civil War had a profound effect upon Hilton Head. When Union forces took over the island, the planters fled, among them Ephraim Baynard. They left almost everything behind, including their slaves. The Union forces were here to provide a fueling depot for ships that were attempting to blockade traffic from Savannah. Union officers took over the planters' homes and began building warehouses, a dock, and a hospital. Soon, the population of the bustling island had ballooned to 50,000. The island was also the mecca for fleeing slaves who had heard that "Mister Lincum" was going to free them.

It was also headquarters for the Union's Department of the South, comprising Georgia, Florida, and South Carolina.

### Gen. P.G.T. Beauregard

If Confederate general Pierre Gustave Toutant Beauregard had gotten his way and the Confederates had access to more money and more armament, perhaps Hilton Head would never have fallen to the Union. After inspecting the South's coastline, Beauregard was impressed by the magnificence and strategic importance of Hilton Head's Port Royal Harbor but doubted that it could be adequately defended—the distance between Hilton Head and Bay Point was too great. Overruled by the governor of South Carolina, Beauregard suggested mooring a steel-clad floating battery halfway between forts on Hilton Head and Bay Point that should be "armed with the heaviest rifled guns that can be made."

On Hilton Head, the battery was laid out according to Beauregard's instructions, under the direction of Maj. Francis D. Lee, with provisions for seven 10-inch Columbiads, smoothbore seacoast guns capable of firing heavy projectiles at both high and low trajectories. Perhaps it was realized that rifled guns would be impossible to procure. To make matters worse, on September 1, when the battery was ready to be armed, only one Columbiad was available. Other essential items failed to arrive, and the idea of the floating battery was apparently forgotten.

Thomas Fenwick Drayton was to command the poorly armed and vulnerable Fort Walker. In early November, knowing that at that very moment the North was assembling a formidable amphibious squadron (which would not be equaled until World War II), Drayton must have walked through the fort with a heavy heart. For there was no doubt that Hilton Head was in the squadron's bulls-eye. (Library of Congress.)

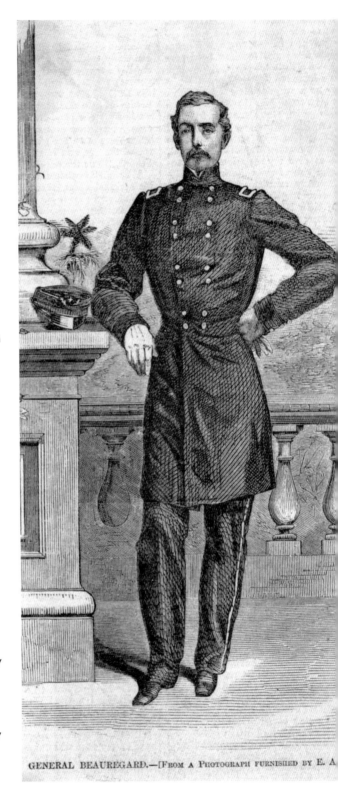

GENERAL BEAUREGARD.—[FROM A PHOTOGRAPH FURNISHED BY E. A

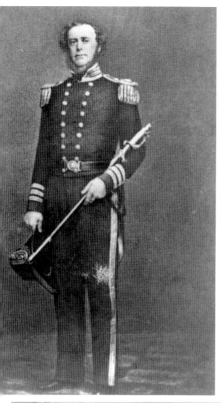

### Samuel Francis Du Pont
Adm. Francis Du Pont, aboard his flagship, the steam frigate *Wabash*, led the invasion of Hilton Head on November 7, 1861. Du Pont ordered his ships to keep moving in an elliptical path, bombarding Fort Walker on one leg and Fort Beauregard on the other. This was followed by ships taking enfilading positions, exploiting a weakness in Fort Walker. By early afternoon, the battle was over. The soldiers in Fort Walker fled, and a landing party took possession of the fort. Seeing this, the commander at Fort Beauregard across the bay ordered the fort abandoned. Du Pont's brilliant tactical success earned him plaudits in Washington, established an effective blockade, and made Hilton Head Island headquarters of the Union's Department of the South and, for a few years, home to 50,000 people. (The population today is only about 33,000—but there are 2.5 million visitors annually.) (Library of Congress.)

### Battle of Port Royal
As part of Hilton Head Island's sesquicentennial commemoration of the battle, this painting of the Battle of Port Royal by Chris Clayton, president of the Lowcountry Civil War Round Table, was used on posters and other printed materials. (Chris Clayton.)

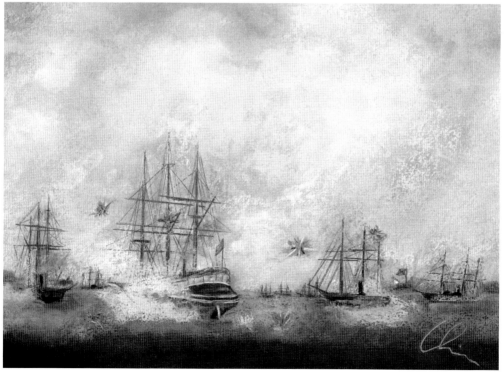

### Percival and Thomas Drayton, Brother Against Brother

Percival Drayton (pictured) was born into a South Carolina family with large land holdings. His father, William, a firm believer in preserving the Union, moved the family to Philadelphia in 1833 following the Nullification crisis. Percival was already in the US Navy, having been appointed midshipman in 1826. By the time of the Battle of Port Royal, he was in command of the gunboat *Pocahontas* and was lobbing shells into Forts Beauregard and Walker, the latter under the command of his brother Thomas. (Library of Congress.)

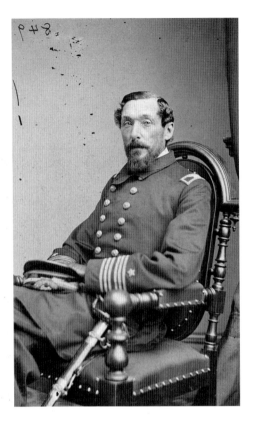

### John Witherspoon

John Witherspoon, a member of the Heritage Library and a resident of Hilton Head, frequently takes the role of Percival Drayton in historical presentations. Channeling Percival, he will say, "I never took a wife, for I was married to the Navy." He also tells of his brother Thomas Drayton's penury—after the war, Thomas was destitute and only survived as a result of a generous gift of cash from his brother Percival. Witherspoon presented Percival on several occasions during the island's 2011 sesquicentennial observations of the Battle of Port Royal. (Author's collection.)

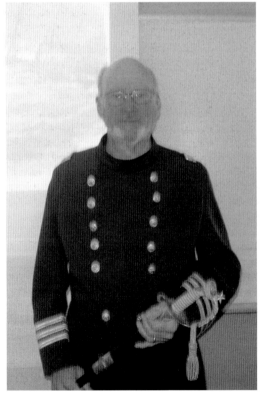

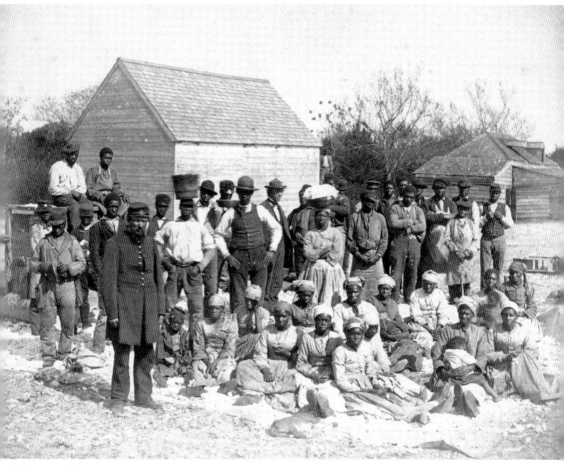

**Thomas Drayton**
Thomas Fenwick Drayton was born in 1809. He was 24 years old and a graduate of the US Military Academy when his father moved to Philadelphia, and he chose to remain in South Carolina. He married Catherine Pope, thus gaining possession of Fish Haul Plantation in Hilton Head. His roommate at the academy had been Jefferson Davis, and when Davis became president of the Confederate States, he named Drayton a brigadier general. At that time, Drayton was living on Fish Haul (or Fish Hall), often referred to as the Drayton Plantation, where he had 102 slaves, some of whom are pictured here with Drayton. (Library of Congress.)

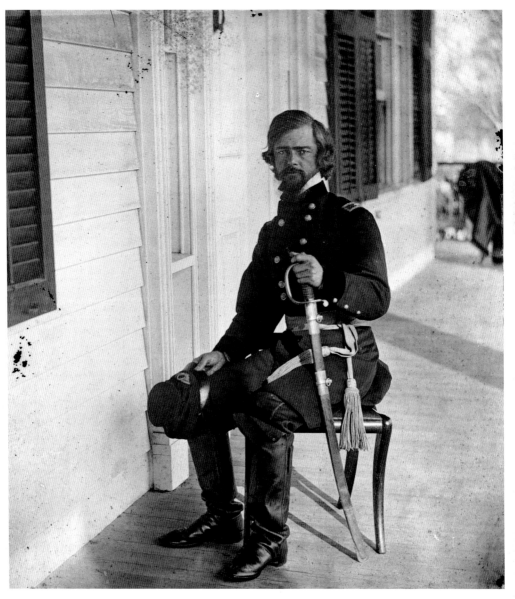

**Gen. Isaac Stevens**
Gen. Isaac Ingall Stevens, one of the commanders at Hilton Head, was a handsome and dashing officer who fought at Port Royal. Of small stature but large controversy, he had previously served as governor of Washington Territory, where his rough treatment of the Indians led a number of powerful citizens to demand his removal. Pres. Franklin Pierce, who had appointed Stevens to the post as a reward for his support of Pierce in 1852, refused to remove him, and Stevens was elected as the territory's representative to Congress in 1857.

When the Civil War broke out, Stevens was commissioned as colonel in the 79th New York Volunteers. After the Battle of Port Royal, he participated in the second Battle of Bull Run. At the Battle of Chantilly in Virginia, he picked up his unit's fallen colors to lead a charge and died instantly from a bullet to the head. (Library of Congress.)

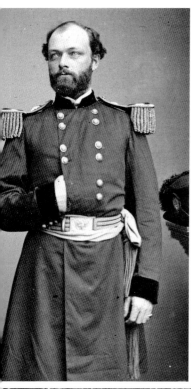

### General Gillmore
Gen. Quincy Adams Gillmore, born in 1825, was named after the president-elect, John Quincy Adams. He attended West Point, where he graduated first in his class in 1849. He came to Hilton Head with Gen. Thomas W. Sherman. An engineer, he had several other assignments before returning to Hilton Head to take command after the death of Ormsby Mitchel. He was in the charge of the black 54th Massachusetts, immortalized in the movie *Glory*. He had ordered that the troops must be integrated and that blacks not be limited to such menial tasks as latrine and kitchen police duty. (Library of Congress.)

### General Gillmore's Tent
This contemporary photograph vividly shows the subtropical environment of Hilton Head Island. (Library of Congress.)

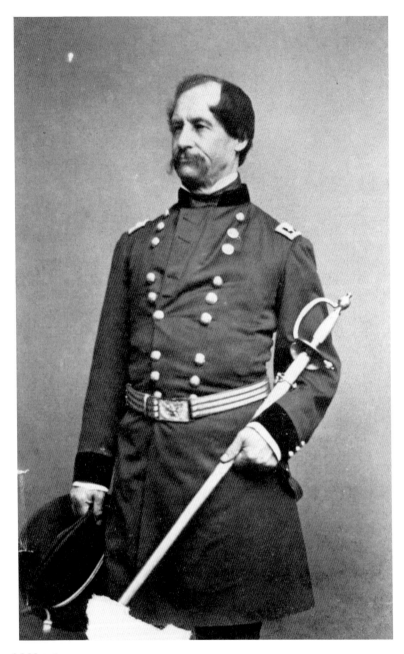

**Gen. David Hunter**
General Hunter held strong antislavery views and had strong connections to President Lincoln. He was also a strong advocate for arming blacks to fight for the Union. In 1862, he was put in charge of the Department of the South, headquartered on Hilton Head. His antislavery position had caused considerable controversy, which erupted further when he issued an order freeing slaves in the three states nominally governed by the Department of the South. Political ramifications caused Lincoln to cancel the order and issue a reprimand to Hunter.

One of the nurses who worked with General Hunter was the abolitionist Harriet Tubman, who was to become famous in her own right. (Library of Congress.)

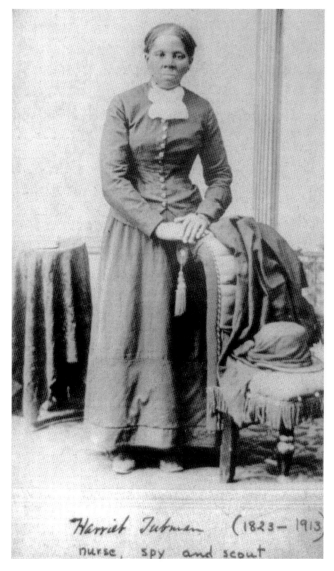

*Harriet Tubman (1823–1913) nurse, spy and scout*

**Harriet Tubman**
She was born Araminta Harriet Ross in 1820 into slavery. As a child, she suffered terrible beatings and a blow to the head that caused seizures and visions. At the age of 29, she escaped from slavery in Maryland to Philadelphia but later returned to help relatives escape. At the outbreak of the Civil War, she decided she wanted to offer her expertise to the Union cause, and with a group of abolitionists from Boston and Philadelphia, she came to Hilton Head, where she became a fixture at Port Royal while David Hunter was in command. She acted as a nurse, tending soldiers with smallpox without catching it herself, and made money by baking pies and brewing root beer at night. She became famous for her role in the raid on plantations on the Combahee River in June 1863. The Confederates had mined the river, but Tubman had mapped the area and led three Union boats, under the direction of Col. James Montgomery, safely around the mines. Once ashore, the Union forces set fire to several plantations. Slaves, hearing the steamboat whistles, understood that freedom was coming and stampeded toward the boats, some still carrying pots of cooking rice and squealing pigs. All told, 700 former slaves were freed that day in June 1863 and brought to Hilton Head. (Library of Congress.)

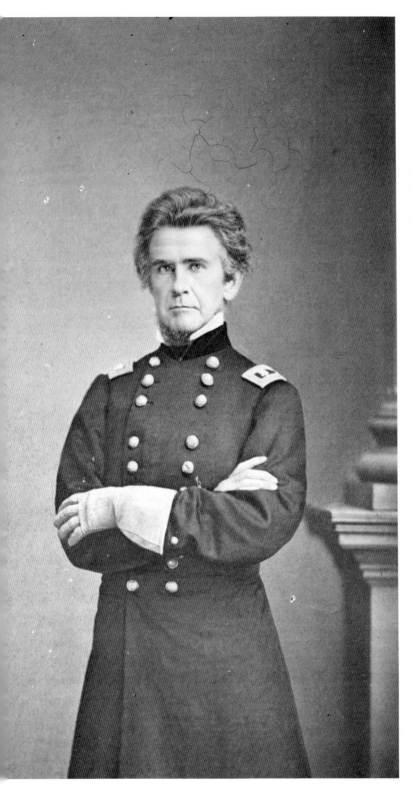

**General Mitchel**
Ormsby Mitchel was a multitalented man, a famous astronomer, and a fervid patriot. He attended West Point and was a classmate of Robert E. Lee. He was an attorney, a surveyor, a professor, and he instituted the first magazine devoted to astronomy.

He was in New York when the news came of the fall of Fort Sumter. Asked to speak at a public gathering, he poured out such eloquent words that his passion had women and men alike openly weeping. It was such sentiments that likely endeared him to the newly freed slaves, for their town of Mitchelville, South Carolina, was named in his honor.

At the outbreak of the Civil War he entered the Army with the rank of brigadier general. One of his most famous deeds was a surprise maneuver in April 1862 that allowed him to capture Huntsville, Alabama, without firing a shot. As a result, he was promoted to major general.

In September 1862, he assumed command of the Department of the South at Hilton Head but died shortly thereafter of yellow fever. (Library of Congress.)

### A Typical Refugee Family

Families like these of Sea Island slaves began pouring into Union encampments, in one case with no clothing other than gunnysacks. Just two days after the Battle of Port Royal, several hundred arrived in Hilton Head. At first, they were regarded as contrabands of war; they were not yet free, but the members of the armed forces did not regard them as chattel or property. Another problem was what to do with them.

At first, they were housed in barracks, but that soon proved to be unworkable. Ormsby Mitchel determined that they should be housed away from the soldiers, and a portion of the Drayton Plantation was set aside. Each family got a quarter-acre, which was large enough for a house and a small garden. Residents built their own houses with planks provided. They also met and decided on rules and elected their own leaders, and they made education of children compulsory. In gratitude to General Mitchel, they named the settlement Mitchelville. (Library of Congress.)

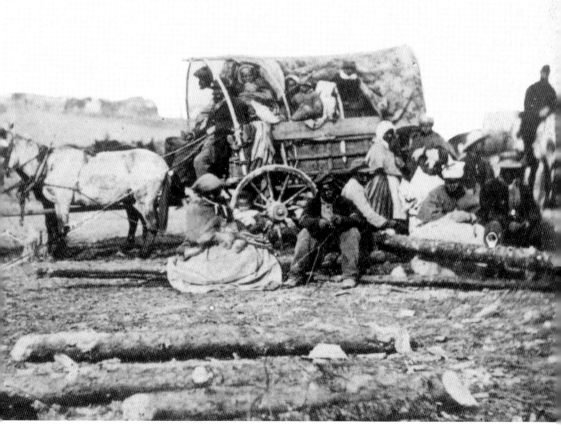

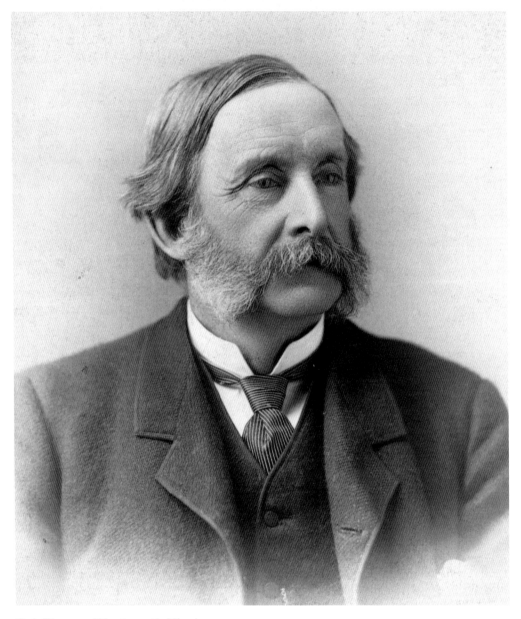

**Col. Thomas Wentworth Higginson**
Thomas Wentworth Higginson was so progressive in his views that some considered him a lunatic. Higginson lost his Unitarian congregation, who felt him too extreme even for that relatively progressive group. He was a militant abolitionist and must have welcomed the call from Gen. Rufus Saxton, then commanding at Hilton Head, to raise a company of soldiers from the newly freed men. He treated the former slaves with dignity and raised the 1st South Carolina Volunteers, which later became the 33rd US Colored Troops (USCT). According to the Reverend A.W. Jackson, who served with him, Higginson was a "born commander" who held his soldiers to strict obedience but also treated them like men. The result, he said, was that "the affection and reverence of his soldiers for their Colonel was beyond words." A famous writer himself, Higginson was later to gain notoriety for editing the letters and poetry of Emily Dickinson. (Library of Congress.)

# CHAPTER FIVE

# The Long Quiet

> [The missionary-teacher Reverend Thomas Howard and his wife] came in March [of 1888]. . . . They took the early morning steamer for Hilton Head . . . eager for the sight of the long pier where the minister had first disembarked [during the war years]. The pier was not there. It had been washed away . . . and never replaced. There was no need for it now. Nobody went to old Port Royal any more. . . . Hilton Head was now the correct postal term, instead of the confusing wartime "Port Royal" although in local talk the name of Mitchelville was often used. . . . The island was truly quiet again after the soldiers went away . . . even the soldiers' graves would be moved to the National Cemetery at Beaufort [from the Union Cemetery on Hilton Head].
>
> —Virginia C. Holmgren, *Hilton Head: A Sea Island Chronicle*

In 1868, Union forces left Hilton Head, and the residents were left to their own devices for decades, making their living by fishing and farming. With little contact with the mainland, the people of Hilton Head became singularly self-reliant and built a remarkably cohesive community. No one locked his house, and crime was nonexistent. With memories of ties to Africa—especially Angola, it is said—the people of Hilton Head preserved a language of their own and a culture that became known as Gullah. The best-known phrase from that language is *kumbaya*, "come by here," immortalized in the song by that name. After the turn of the 20th century, wealthy Northerners began buying up or leasing large sections of Hilton Head for a hunting and fishing playground.

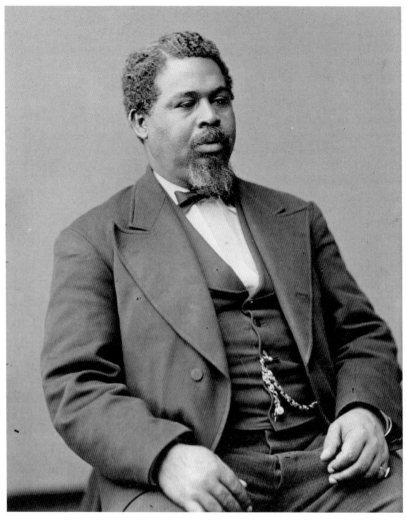

**Robert Smalls**

Robert Smalls represented Hilton Head when he served in the South Carolina legislature in the 1860s and the US Congress in the 1880s. His rise to political power had been preceded by a daring escape and invaluable service to Union forces during the Civil War.

Then the property of Henry McKee of Beaufort, in 1851 at the age of 12, Smalls was sent by McKee to Charleston to be hired out, the money he earned to be returned to McKee. Working on the docks, Smalls eventually worked his way up to "wheelman," which was really a pilot. In the fall of 1861, he was assigned to pilot the CSS *Planter*, a Confederate armed military transport. Small's opportunity came the following May, when the officers of the ship, contrary to regulations, decided to sleep ashore. Smalls disguised himself as a captain, donning a captain's uniform and a hat similar to the one the captain habitually wore. In the dark of the night, Smalls and the enslaved crewmen backed the *Planter* away from the wharf and stopped at a nearby wharf to pick up his family and relatives of the crew who had been concealed there. With his knowledge of the locations of mine and torpedoes, he threaded the *Planter* through treacherous waters. Dawn found him standing on the deck in the typical stance of the captain, with arms akimbo. Confederate boats let him pass when he blew the appropriate signals on the boat horn. He headed straight for the Federal fleet, where he was met by the USS *Onward*, surrendered, and requested the US flag be raised on the *Planter*. Smalls, his family, and all the crew were safe—and free. (Library of Congress.)

## Clara Barton

Many islanders dated events before or after the Great Sea Storm of 1893, in which as many as 2,000 people are believed to have perished. (There is no accurate count to this day.) On August 28, winds of 120 miles per hour devastated Hilton Head and the surrounding islands, making it a Category 3 hurricane. Most of those who perished did so in the storm surge.

It was October 1 before Clara Barton and the Red Cross arrived; she was no stranger to Hilton Head, having served here during the Civil War. She found survivors who had lost absolutely everything, with no place to go back to. Many had somehow made it to the Red Cross headquarters in Beaufort, where they milled outside the building in a great moving but silent crowd. A writer from *Scribner's* was puzzled by the lack of voices rising from the people. He wrote, "If the puzzle brings a frown to your face, as it did to mine, an old Auntie will look at you steadily until she catches your eye, and then, dropping a courtesy, will exclaim: 'You look worry, suh!' And then, when you turn to her for an explanation, 'I bin worry myse'f, suh. Many time.' "

The writer was impressed by these people, saying they know "how to be good-humored without being boisterous, and [have] the rare gift of patience."

Barton moved the food distribution sites from Beaufort to the islands to lure people back home. Through a massive relief campaign lasting 10 months, most of the survivors had homes and were producing their own food again. Damages from the storm totaled at least $1 million in 1893 dollars. (Library of Congress.)

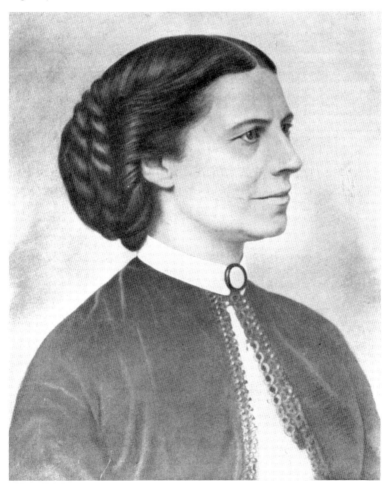

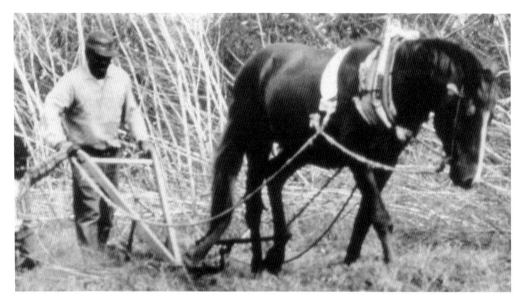

**The Marsh Tacky**
Truly a legend in its own right, the Marsh Tacky is unique, having been proved by DNA to be a descendant of the small horses left by the Spanish in the 1500s. Sure-footed in marshy country, unlike larger horses, smart and easily trained, they have been at once the companion and the essential worker for the Sea Island Gullahs. Talks by Natalie Hefter of the Coastal Discovery Museum often demonstrate the Tacky by showing this photograph of an earlier resident plowing. Once she asked a group of children, "What do you think this man is doing?"

"I know," piped up one little boy. "He's walking his horse." (Coastal Discovery Museum.)

**Marsh Tacky Races**
Around Christmas time, it became a tradition for native islanders to race their Marsh Tackies, a tradition that continues. This horse is Strawberry, ridden by Ashley Lowther about 2009. The Marsh Tacky has been named the official Heritage Horse of South Carolina. (Carolina Marsh Tacky Association.)

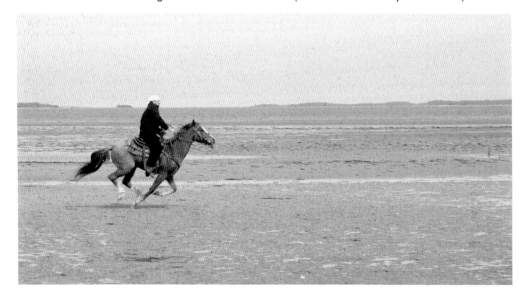

CHAPTER FIVE: THE LONG QUIET

**Alfred Loomis**
Beginning in the 20th century, Hilton Head Island stirred and stretched but was not quite awake as wealthy Northerners began to buy up or lease land for hunting and fishing. Alfred Loomis and his brother-in-law Langdon K. Thorne purchased 17,000 acres and created a private preserve for riding, boating, fishing, and hunting. It was headquartered at the old Honey Horn Plantation.

Loomis was an investment banker, an attorney, a scientist, and a pioneer in military radar usage. He was a coinventor of the microscope centrifuge and was involved in many scientific advancements, including LORAN, electroencephalography, biological instrumentation, and the Manhattan Project. As chairman of the Microwave Committee, he selected a building on the MIT campus for a radiation laboratory, called the Rad Lab, where he pushed for development of radar despite skepticism on the part of the Army. Shortly after the war, Loomis retired to private life, never giving another interview, and he sold his land in Hilton Head in 1949. (Library of Congress.)

### William Hurley

A wealthy hunter from up North, William Hurley, owner of a chain of department stores in New Jersey, had a huge hunting preserve of nearly 5,000 acres in Hilton Head, some leased and over half purchased outright. Here, he entertained friends and business associates with hunting, picnics, swimming, and enjoyment of the lush semitropical environment. He so loved the island that he retreated there during his final illness.

The land was sold to Loomis and Thorne in 1931 and would be held by them until the Hilton Head Company bought it and began timbering. (Sara Lee Murphy.)

### Hurley Lodge

A notation on the bottom says, "Papa bought this place from Charlie Myers."

Despite the limited amenities, the Hurley hunting lodge was relatively comfortable, with central steam heat (wood-burning), a Victrola, and electricity supplied by a Delco plant. The dining room seated 14; there were four bedrooms and adjacent quarters for servants. (Hurley family.)

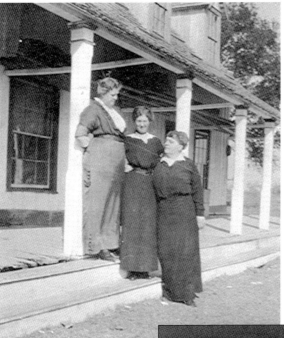

**Sara Hurley and Daughters**
Pictured are Sara Hurley, wife of William Hurley, on the top step, Genevieve Hurley (center), and Mary Hurley. (Hurley family.)

**Sara Hurley**
Sara Pauline Kirby Hurley, wife of William Hurley, was a perfect exemplar of the handsome matron and social leader of the Gilded Age, right down to the rope of pearls. Her great-granddaughter Sara Lee Murphy says most of Sara Hurley's diamonds are still in the family, but "we don't know what happened to the pearls." (Sara Lee Murphy.)

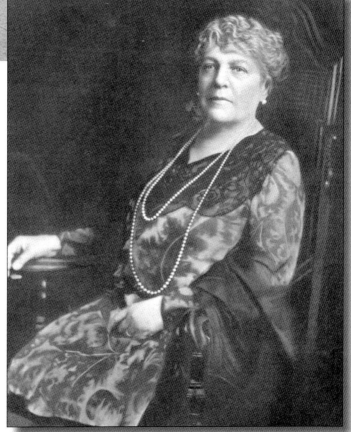

## Charlie Simmons

Charlie Simmons was a true legend. He was a vital link to the mainland in Savannah, widely known to islanders as "Mister Transportation." He had worked on ferries as a young boy and, in the 1920s, began his own service to the mainland using a sailboat. In 1927, he bought the *Lola*, a 33-foot boat with a 15-horsepower motor, for service to Savannah. He also hauled islanders' produce to Savannah, where he would sell the produce, shop for the islanders, and bring back the things they needed. (*Island Packet*.)

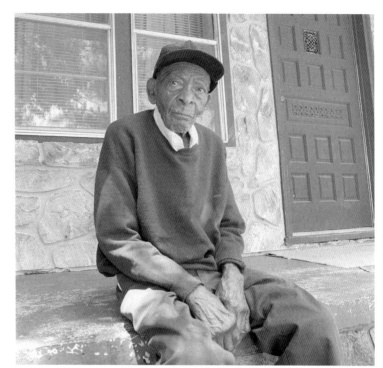

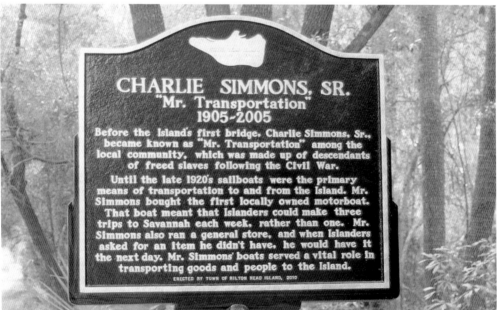

## Simmons Marker

Unveiled in 2010, this marker reads in part: "Until the late 1920s, sailboats were the primary means of transportation to and from the Island. Mr. Simmons bought the first locally owned motorboat. That boat meant that Islanders could make three trips to Savannah each week rather than one. Mr. Simmons also ran a general store, and when Islanders asked for an item he didn't have, he would have it the next day." (Author's collection.)

## CHAPTER FIVE: THE LONG QUIET

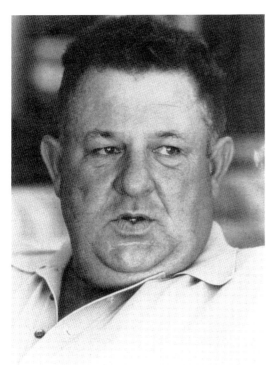

**Benny Hudson**
One family whose members played significant roles in Hilton Head during the quiet years and the early development years were the Hudsons. Benny Hudson's family had long lived on Hilton Head, a hardworking family supplying seafood. The Hudsons were one of the two largest employers on the island. It was said, "You either worked for the Hudsons or the Toomers." (The Old Oyster Factory restaurant on Hilton Head is on the old site of the Toomers' oyster factory.) (Hudson family.)

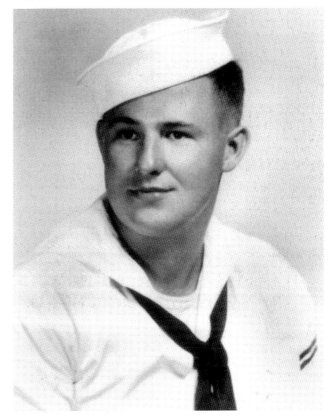

**Benny Hudson in World War II**
The Hudson family had lived by, on, and from the sea on Hilton Head, and it seemed only natural that young Benny Hudson would join the US Navy. (Hudson family.)

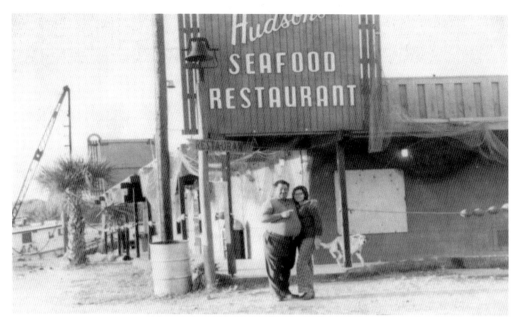

**The First Hudson's Seafood**
The Hudsons had been a tradition on Hilton Head since the 1920s, when J.B. Hudson Sr. operated a seafood processing plant. In the next generation, Benny Hudson and Barbara Hudson opened Hudson's Seafood Restaurant. Close to the docks where the Hudson boats unloaded their catches of shrimp and fish, the restaurant guaranteed its patrons freshness. Today, fifth-generation family member Tonya Hudson-DeSalve continues the Benny Hudson name, supplying fresh shrimp and fish in season for Hilton Head tables. (Hudson family.)

**When the Bridge Was Out, Islanders Made Do**
Islanders needed to have their wits about them. The cooking oil Benny Hudson needed for his restaurant was in Savannah, and the swing bridge was not operating. When Hudson heard that a helicopter operator wanted a landing place on the island so he could sell tours in his machine, Hudson told him, "I have a flat roof where you can land if you'll bring me my cooking oil." The pilot was glad to oblige. (Hudson family.)

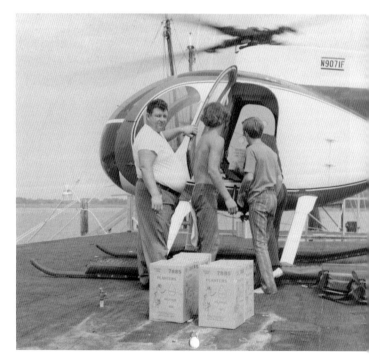

# CHAPTER SIX

# Bringing the Necessities

*When Charles Fraser first explored the forests and swamps [of Hilton Head], there was only one paved road . . . only eleven cars and trucks, about 100 Marsh Tackies, no electricity, no telephones and no medical facilities.*

—Margaret Greer, *The Sands of Time: A History of Hilton Head Island*

When development began on Hilton Head, virtually everything started from scratch. There was very little there with which to begin construction. Electricity and telephone service had to be brought in. New roads had to be laid out and paved. In a way, it was fortunate that there were very few buildings, for that allowed planners to design communities in a logical fashion. It was fortunate for Hilton Head that some of those early planners were visionaries who saw the island's beauty and were determined to preserve it.

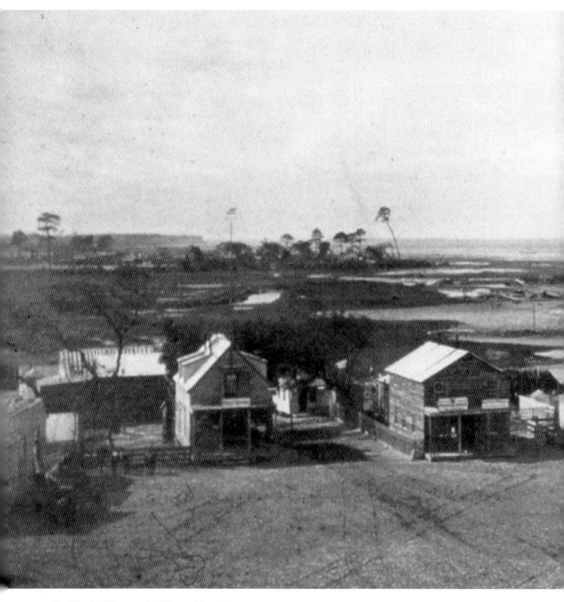

**An Early View of Hilton Head**
This undated waterfront photograph appears to have been made before development began in earnest. Note the rather random wagon tracks on the unpaved expanse before the buildings. There are ships and sailboats in the harbor, so presumably some of the buildings were devoted to seafood processing. It is likely that either or both of the primary employers on the island at the time, the Hudsons and the

CHAPTER SIX: BRINGING THE NECESSITIES

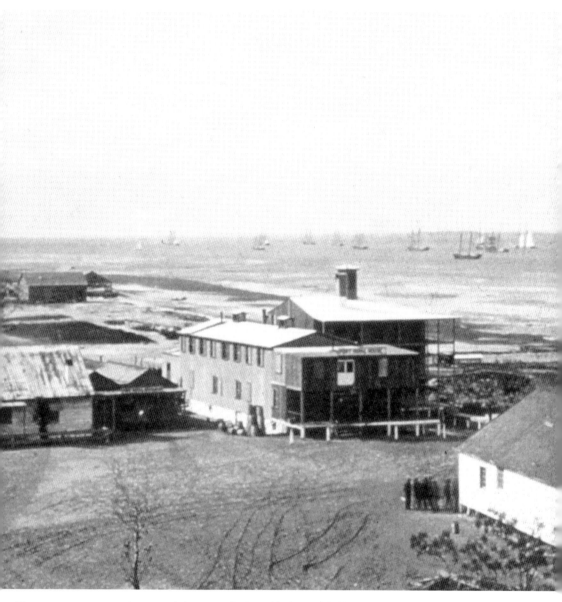

Toomers, were operating out of this area. Barbara Hudson said, "We were the only employers; you either worked for the Hudsons or the Toomers." Both families eventually opened restaurants. Hudson's Seafood still exists (page 45); the Toomers' restaurant, the Boiler, became the Crazy Crab (page 56). (The Lowrey Group.)

**Fred Hack**

It all began in 1949, when Fred Hack, owner of a timber business in Georgia, heard that Alfred Loomis and his brother-in-law Langdon Thorne, who had assembled 17,000 acres on the island, were putting it on the market. Hack persuaded others in the timber business, including Gen. Joseph Fraser, to buy 7,000 acres in 1949 and another 11,000 in 1950. They paid an average of $60 an acre. At the time, there was no access, no electricity, and no telephone service. The group lobbied the state for a bridge, and a swing bridge opened in 1956.

The owners soon realized that their business on the island would not be timbering but development, and aesthetics were a consideration in cutting trees. "They were not perfect environmentalists by today's standards," said Frederick Hack, son of Fred Hack, "but for the time, they were pretty good land stewards." (Frederick Hack.)

CHAPTER SIX: BRINGING THE NECESSITIES

### Lois and Norris Richardson
Lois and Norris Richardson arrived in Hilton Head in 1956, a few months before the bridge opened. Both with backgrounds in grocery retail, they had decided to make Hilton Head their home and to open a store here. Richardson had the materials for the store barged over from the mainland at a cost of $5,000, a considerable sum for those days. Lois said of those early days, "Even after the store was stocked, it still had a pretty good echo most of the time. Sometimes you could go all day and not sell so much as a loaf of bread." A Piggly-Wiggly store now sits on the original site. (Richardson family.)

### Fountain at Coligny Plaza
Where the Red and White store one stood, the Richardson family has created a complex of over 60 shops and restaurants. Here they emphasized the island's natural beauty with such details as a soothing and pleasant fountain. (The Richardson Group.)

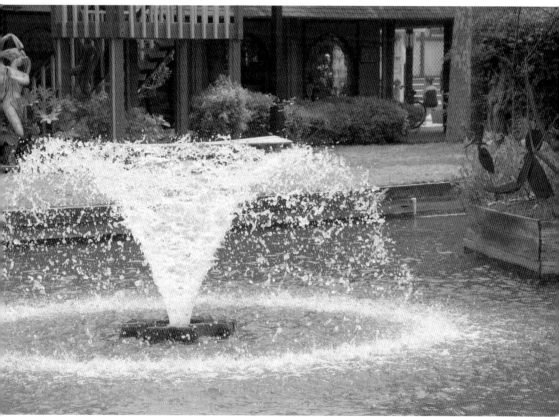

### Peter Lamotte

The story is told that, in 1970, Peter Lamotte was passing by Hilton Head on the Intracoastal Waterway when he happened to attend a local cocktail party and met Charles Fraser. When Fraser learned that Lamotte was chief of trauma surgery and chief of orthopedic surgery at New York City's Roosevelt Hospital, he said to Lamotte, "Why don't you open a hospital here?" Two days later, Peter and Beryl Lamotte bought property on Hilton Head. Fraser realized that, if Hilton Head were to attract permanent residents, excellent medical facilities would be necessary, especially for retirees. In 1975, a 40-bed nonprofit hospital opened. (Beryl Lamotte.)

### Hilton Head Hospital Auxiliary

The Hospital Auxiliary does more than staff the gift shop and other volunteer efforts. It also provides scholarships to the Technical College of the Lowcountry (TCL). Since 1995, it has given the TCL Foundation $328,128 in funds to help students in the nursing, radiologic technology, physical therapy assistant, surgical technology, and massage therapy programs. Pres. Dottie Gottdenker, on the left, is shown below with the Auxiliary's first president, Kiftie Stephens. (*Hilton Head Monthly*.)

CHAPTER SIX: BRINGING THE NECESSITIES

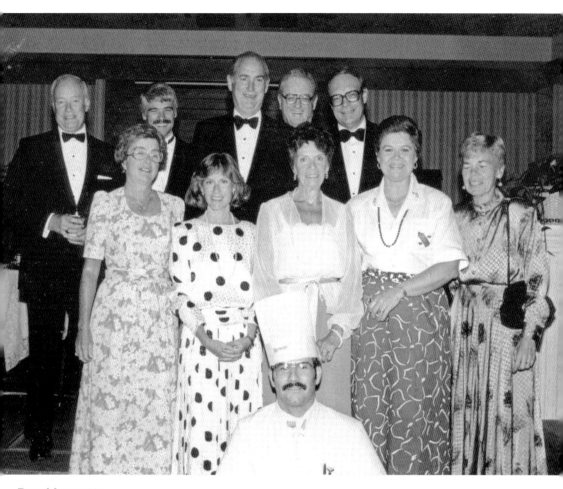

**Beryl Lamotte**
There were lean times when the hospital opened in 1975, and there were many campaigns just to keep the doors open. According to Beryl Lamotte (fourth from left in the first row), they had to wage continual campaigns to raise money, sometimes just to pay the electricity bill. One of the first campaigns was a gala, planned as the Marriott was being built. Angus Cotton was the general manager of the Marriott at the time, and as the date for the gala drew near, the home office decided the hotel was not ready for the event and sent word to Cotton to cancel the event.

The planners were aghast. Everything was lined up, tickets were sold, and the hospital desperately needed the money. They decided that the show must go on. And it did. Beryl did not stop there; she is still active in community organizations.

Pictured are the gala are, from left to right, (first row) Nancy Brost, Joni Banks, unidentified, Beryl Lamotte, and Beverly Cotton; (second row) Bob Brost, Ben Banks, unidentified, Peter Lamotte, and Angus Cotton. The chef sitting in front is unidentified. (Beverly Cotton.)

### Angus Cotton

Besides being involved in the hospital and managing the Marriott, Angus Cotton was a bundle of civic energy. He came here in 1980 as, according to David Lauderdale of the *Island Packet*, "a poster child for the in-migration of human capital that has transformed" the area. Jovial, outgoing, loved by his fellow workers, he was a natural for the hospitality industry. Like so many arrivals, he dedicated himself to bettering the community. When Sea Pines fell upon hard times as a result of some complex wheeling and dealing, Cotton was one of those who helped rescue the community by getting the 670 residents to buy Sea Pines. Cotton also worked with Joe Fraser to establish the Heritage Classic Foundation, which produces the annual golf classic. He and his wife, Beverly, were honored together with the Alice Glenn Doughtie Community Service Award, given by the local chamber of commerce.

But perhaps his most enduring success is the Technical College of the Lowcountry (TCL). TCL grew out of a 19th-century school for daughters of former slaves. When Cotton became chairman of the board, he brought his hospitality leadership style to the school. According to observers, he changed the focus from "Here are our classes; come get it" to "What do you need and how can we best teach you?"

In gratitude, TCL named its building the Angus Cotton Academic Center. Friends of Cotton have started an Angus Cotton Endowment Fund to insure the school will always have the latest technology. (Cotton family.)

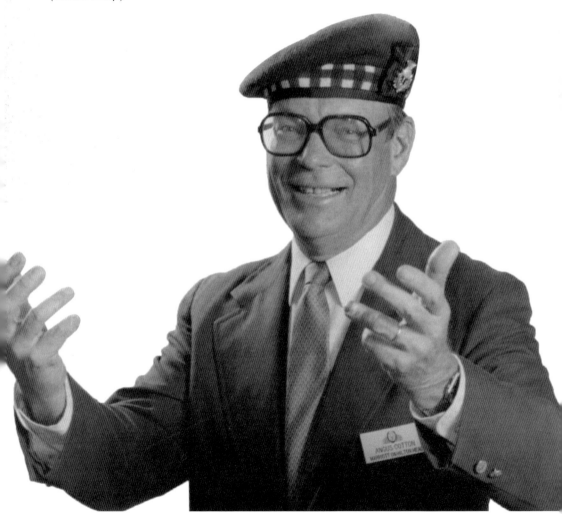

CHAPTER SIX: BRINGING THE NECESSITIES

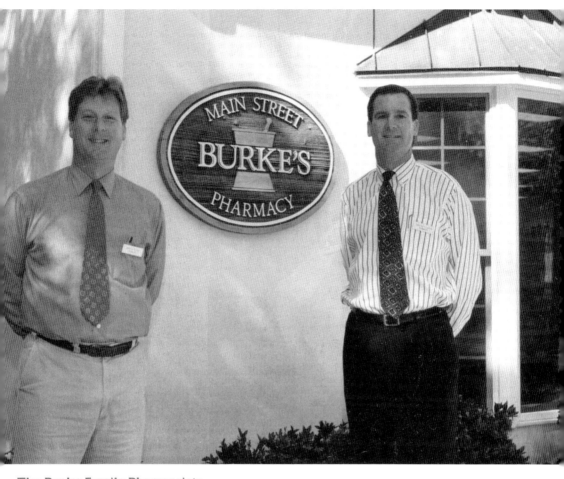

**The Burke Family Pharmacists**
Residents of Hilton Head feel a special relationship with Burke's Pharmacy. It is family-owned and civic-minded. William Burke had moved to Hilton Head in 1983 but found that retirement did not suit his passion for work and community involvement. His sons Tim Burke (right) and David Burke (left) had also become pharmacists, and in 1987, the three of them opened Burke's Pharmacy. Residents shook their heads and declared, "They'll never make it."

But over the years, it became the go-to place not only for prescriptions and hard-to-find items but also for home medical equipment. It even delivers. With the largest staff of pharmacists on the island, it serves skilled care and assisted living facilities. The pharmacy also serves as an experiential rotation site for numerous pharmacy schools, including the University of South Carolina, the Medical University of South Carolina, the University of Connecticut, the Ohio State University, and Ohio Northern University. It is thus helping create a new generation of pharmacists.

Today, Tim and David manage the business, but many other family members also contribute their knowledge and talent. (Burke family.)

### Bishop Ernest Unterkoefler and the Church of the Crazy Crab

Hilton Head Catholics are in the Diocese of Charleston. Ernest Unterkoefler (1917–1993) served as bishop from 1960 to 1990. He is remembered for his civil rights activism, ending racial segregation in all Catholic institutions in the diocese. Noting the growth on Hilton Head, served by only one church, Holy Family Church, the diocese sought a site for a new church in the northern part. The restaurant Crazy Crab, a successor to the Boiler operated by the Toomer family, had recently been opened in the north end. The diocese approached Tom Reilley (see page 63) about holding mass there. The owners readily agreed, and for about four years both, Sunday and daily masses were held there. Some called it "Holy Crab," others "the Church of the Crazy Crab." When the congregation grew to 100 families, they had to find a larger space. (Diocese of Charleston.)

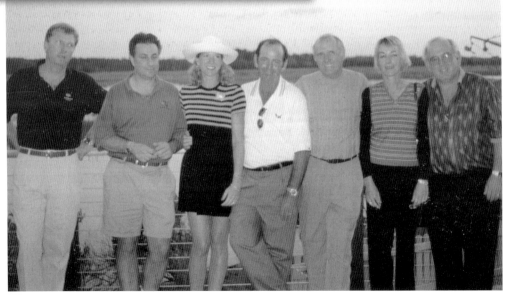

CHAPTER SIX: BRINGING THE NECESSITIES

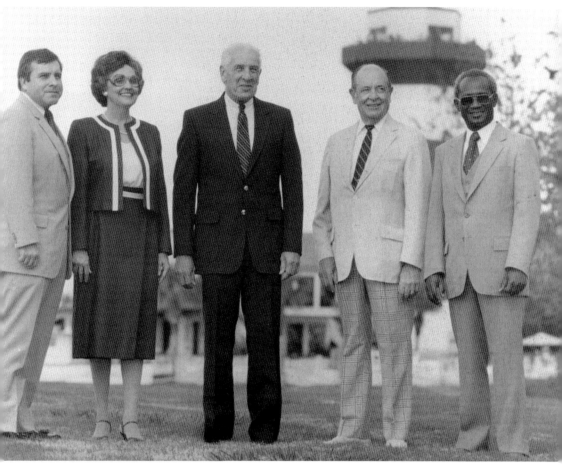

**First Town Council**
From left to right are attorney Wes Jones, Nancy Ann Ciehanski, Mayor Ben Racusin, Harry Hazelton, and Henry Driessen. Hilton Head is part of Beaufort County and, for years, had been governed by the Beaufort County Council, a long ways away. By the 1970s, many people felt that the county government was too far away and did not share the islanders' concerns about unbridled growth. A committee was formed to explore incorporation and concluded it was doable. Islanders decided on a nonpartisan government and held an election, and the first town council met in Mayor Ben Racusin's home in 1983. (Town of Hilton Head Island.)

**Restaurateurs** (OPPOSITE PAGE)
These people helped make the Crazy Crab and were closely associated with several other restaurants on the island. From left to right are Chuck Larsen, Eric Spector, Karen Kenneweg, David Reilley, Peter Kenneweg, Diane Reilley, and Tom Reilley. (Tom Reilley.)

### Ben Racusin

The first mayor of the Town of Hilton Head served in the Air Force during World War II. While posted to China, he met Helen Schuler in Shanghai. "We met on December 9, and on New Year's Eve, I asked her to marry me," Racusin said. He was involved in island affairs for many years and was one of those who helped organize a study that led to the incorporation. It was fitting, when the town council finally had its own chambers, to name them after the town's first mayor. (*Island Packet.*)

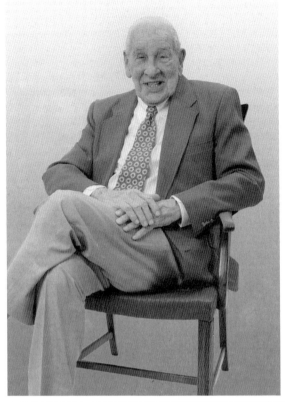

### Nancy Ann Ciehanski

According to Buzz Carota, in that first town council, only Nancy Ann Ciehanski, who was named mayor pro tem, and Harry Hazelton had prior municipal government experience. But the other members included lawyer Wes Jones and native island businessman Henry Driessen. Ciehanski was very active in island affairs even after moving to Sun City. She is shown here with presidential candidate Steve Forbes. (*Ciehanski family.*)

CHAPTER SIX: BRINGING THE NECESSITIES

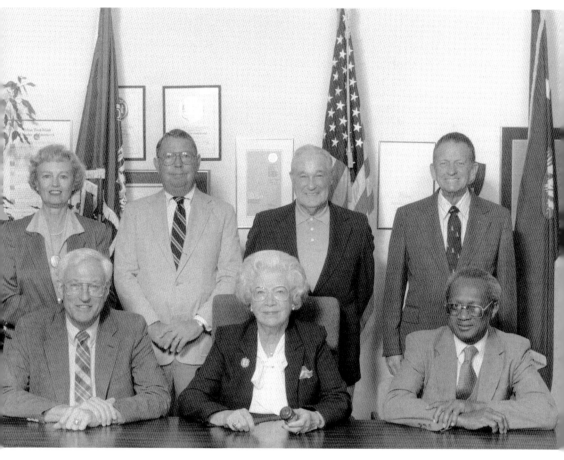

**Baumberger Council**
Pictured are, from left to right, the following: (first row) Bill Marscher, Martha Baumberger, and Henry Driessen; (second row) Libby Johnson, Russ Condit, Buzz Carota, and Jerry Dunn. The Baumburger council served from 1987 to 1989. Bill Marscher was mayor pro tem; a native of Beaufort County, he had returned to Hilton Head and become active in island affairs. Russell Condit moved to Hilton Head in 1985 and, like so many others, plunged into public service, serving three terms on the council and five years on the Hilton Head Foundation Board. Henry Driessen also served three terms. Libby Johnson was a member of several island groups and was listed in *Who's Who of International Women* in 1989. Jerry Dunn was a career Army officer who enjoyed his service on the council. (Town of Hilton Head Island.)

### Martha Baumberger

A remarkable woman with a remarkable career, Martha Baumberger met her husband, Bob, when they were both working for the Cincinnati Planning Commission. Their subsequent careers took them to many diverse communities, including Iran, but like so many people, they fell in love with Hilton Head and moved here in 1978. For the rest of her life, she was active in political and civic affairs; in 1988, she was chosen one of the country's mayors in the People to People program with Russia. (Baumberger family.)

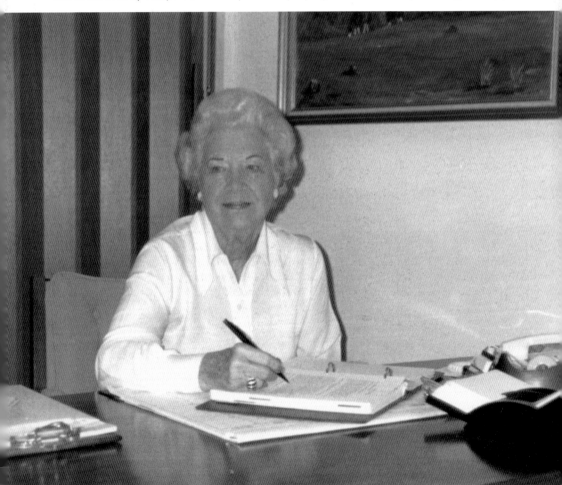

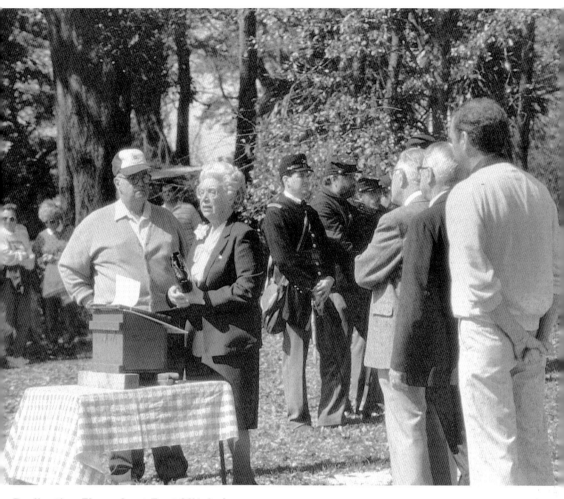

**Dedicating Flagpole at Fort Mitchel**
Martha Baumberger, then mayor of Hilton Head, was there to dedicate the flagpole installed at Fort Mitchel, next to Old Fort Pub. The ceremonies included a "battle" staged by cadets from the Citadel. The fact that Fort Mitchel never saw military action "did little to diminish the enthusiasm of the cadets, all dressed in period costumes. Rebel yells and Yankee shouts filled the air, along with black powder charges exploding in 'the battle,' " according to Paul deVere. For more on Old Fort Pub, see page 78. (Photograph by Bill Littel.)

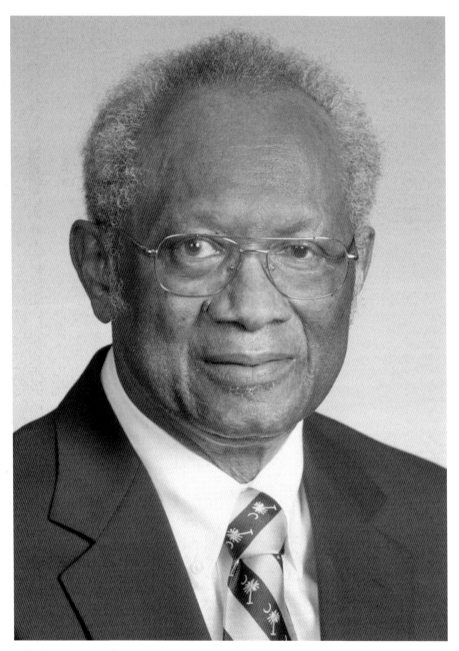

**Henry Driessen**
Another islander with a remarkable career of service is Henry Driessen. He was born and brought up on the island, so he knows it intimately. He served in the medical corps during the Korean War. On a three-day pass, he married his wife, Phoebe Ruth Wiley, whom he had known all his life. He was PTA president of the first integrated high school. When Ben Banks, then publisher of the *Island Packet*, approached him to run for the town council, Driessen may have had mixed feelings, as many native islanders were opposed to the incorporation. But Driessen concluded, "I didn't want to see the black community not represented in town government." He represented them well, according to Buzz Carota, with practicality and a great sense of humor. Today, he is on the board of the Palmetto Electric Cooperative. (Palmetto Electric.)

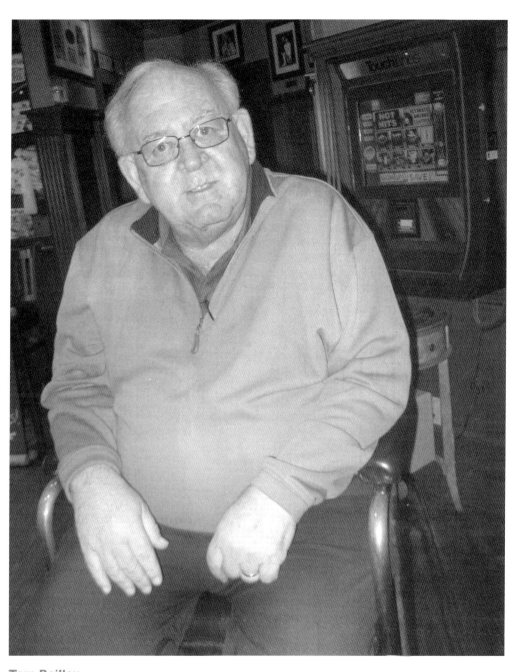

**Tom Reilley**
Tom Reilley's name means "restaurant" on Hilton Head Island. He started his career in the food business as a food salesman; when the company he represented began to fail, he looked around for another opportunity. "I had four kids to feed," he said. So in 1982, with the help of some friends, he started the first Reilley's Restaurant. It was from there that, the following year, he inaugurated the St. Patrick's Day Parade (see Page 64). The restaurant grew and expanded into a location across the street. Later, he added a Reilley's on the north end of the island; he is associated also with the Crazy Crab in two locations. His son is associated with yet another restaurant, Aunt Chilada's. (Tom Reilley.)

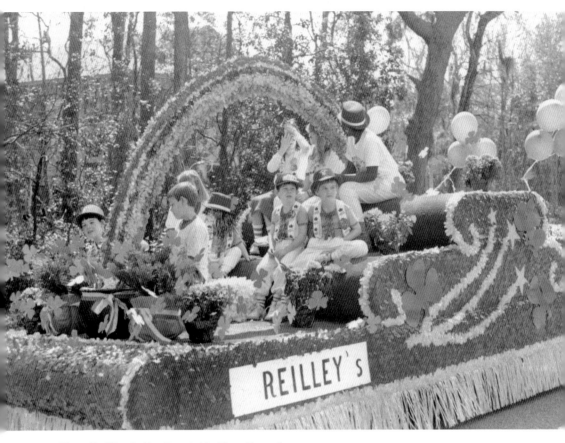

**Tom Reilley's St. Patrick's Day Parade**
Tom Reilley's name is inextricably linked to the popular St. Patrick's Day Parade. The first one assembled at Reilley's Restaurant shortly after it opened. The Town of Hilton Head Island had just been incorporated, and it never occurred to the small group who paraded that day that they would need a permit to march down the street. A deputy sheriff stopped them and demanded paperwork. The group explained they had the best of intentions, the officer relented, and the parades continue to this day (but with permits). It has grown in size and sophistication and is one of today's most popular events on the island, drawing about 20,000 spectators along its route. (Tom Reilley.)

# CHAPTER SEVEN

# A Philosophy of Development

*"I felt you could be economically successful developing this beach either way, ugly or beautiful," [Charles Fraser] said in an interview with* Southern Living *magazine. "There's no law of economics that says ugliness pays. I selected beauty and set out to make it work economically."*
*His instinct for quality became legendary. At great expense, he reduced the size of the yacht basin to save a single oak tree. He established policies to protect alligators without needlessly endangering people.*

—New York Times, *December 19, 2002*

The genius of Charles Fraser's plan of coastal development, considered naive by many at the time, was to preserve wide swaths of the existing forest, seamlessly blending development into the island's natural beauty. Houses were to be painted in subdued earth tones and have large windows. Each homesite was to have a great view of marsh or marinas or golf courses or lagoons. Roads were to be winding and beckoning; glaring advertising and light pollution would be forbidden. To insure that his vision would last, Fraser insisted on strict deed restrictions.

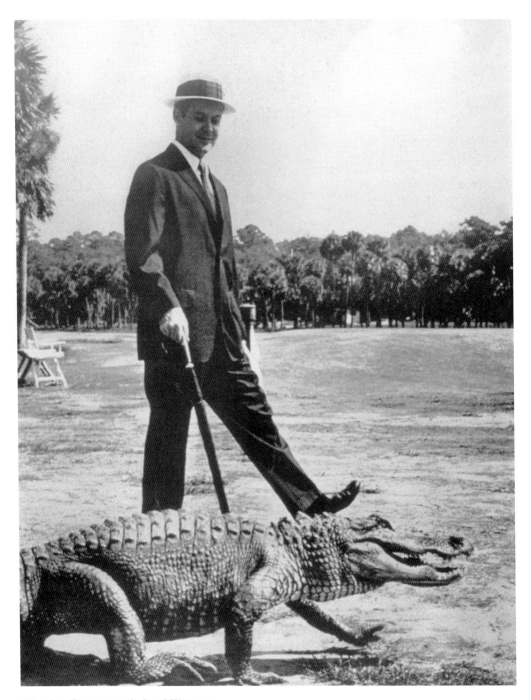

**Charles Fraser and the Alligator**
Charles Fraser, bringing potential investors and buyers to the island, would expound his theories of development, which included living with a natural environment as unchanged as possible. This photograph, with Fraser nattily dressed, may not accurately represent the distance between him and the alligator, but it certainly is an accurate representation of his philosophy of living with nature. It has become so iconic that it is reproduced in a sculpture in the town's Compass Rose Park. (Fraser family.)

**Fred and Billie Hack**
Fred and Billie Hack could be considered a pioneer family in the development of Hilton Head. They moved here in the 1950s, one of the first nonnative families to do so. She was the daughter of C.C. Stebbins, one of the timbermen in the group that formed the Hilton Head Company to purchase land from Loomis and Thorne. She was "a real, gentle, loving Southern lady," said one of her associates. The Hacks lived at the old Hanahan Plantation, whose name had been transmuted to Honey Horn. It had one of the oldest buildings on the island and no electricity when the Hacks first moved in. For many years, Billie was the official rain gauge keeper for Hilton Head. See page 117 for her work with the Bargain Box. (Frederick Hack.)

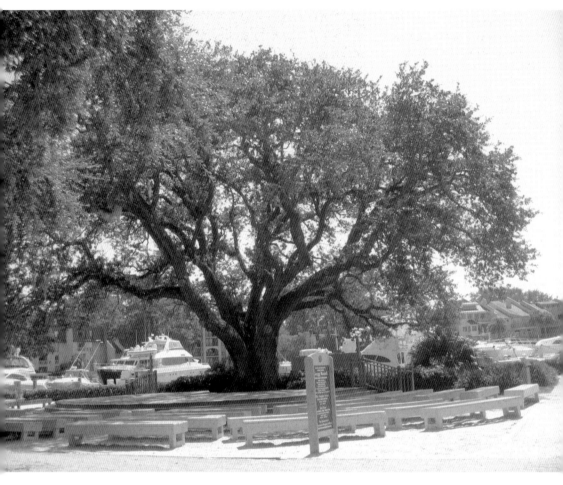

### Charles Fraser and the Liberty Oak

Charles Fraser envisioned the yacht basin in Harbour Town as an intimate harbor village with the ambience of a Mediterranean port. He flew his design team over ports in Italy and southern France to acquaint them with his vision. The harbor was originally supposed to be round but was reshaped to save this ancient live oak. It was reported that saving this tree cost Fraser $50,000. It is often the scene of entertainments and weddings.

It is fitting that the site is also the grave of Charles Fraser, graced with a bust of him by Ralph Ballantine. (Author's collection.)

## Howard Davis

Howard Davis, a highly decorated general during World War II, collected many awards for civic service on Hilton Head. He is perhaps best known for his development of Hilton Head Plantation. When he took it over, rescuing it from bankruptcy, the master plan called for 16,000 dwelling units, but fortunately, only 34 had been built—fortunate because the plan was far too dense. Determined to create a sense of community, Davis pared it down to 4,000. Nine years later, the plantation had 3,500 homes. His community honored him with the Alice Glenn Doughtie Good Citizen Award; his many other awards included the Chairman's Leadership Award from the Hilton Head Island Foundation. (Davis family.)

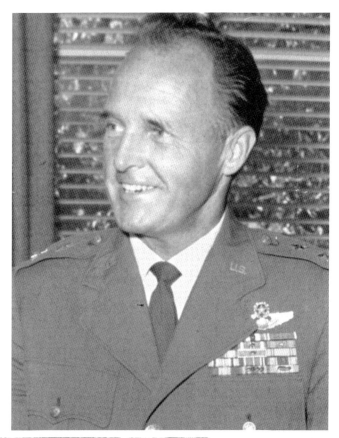

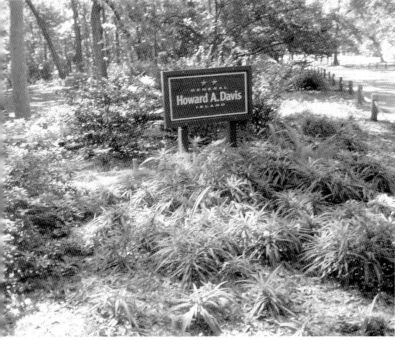

**The Howard Davis Island** This traffic island on Whooping Crane Drive was beautified by plantation residents and dedicated to Howard Davis. (Author's collection.)

**Robert Onorato**

Robert Onorato is one of those dynamos that Hilton Head Island seemed to attract. He was hired as president of Palmetto Dunes Resort in the 1970s, and he had a vision. Highway 278 sort of split the island, and Onorato saw a hotel on the Atlantic side and a marina on the other side, at Broad Creek.

What eventually emerged was Shelter Cove marina, the site of many community celebrations, three golf courses, and a set of tennis courts. Sand dredged from Broad Creek was used to renourish the beaches on the Atlantic side. Every Tuesday at sundown, residents gather to watch the fireworks, which can be heard all over the island.

Palmetto Dunes has 11 miles of lagoons that are popular with kayakers who come to see the egrets and other waterfowl. (Robert Onarato.)

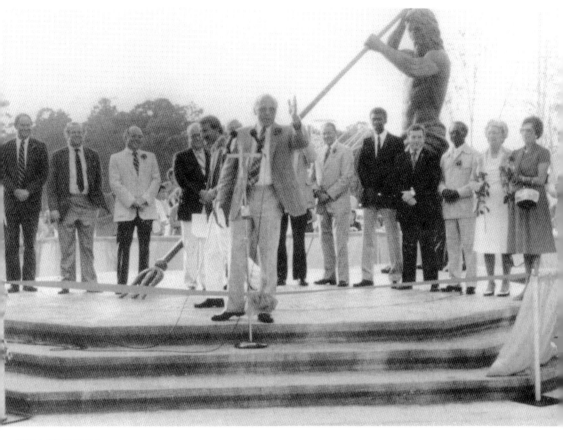

**King Neptune**
A distinguishing feature of Palmetto Dunes is the larger-than-life-size King Neptune statue. It was sculpted and installed by Wayne Edwards, who placed it on a circular mount so that the shadow of Neptune's trident showed the time. Believed to be the world's largest figurative sundial, the statue was originally cast at a foundry in Princeton, New Jersey, and shipped by truck to Hilton Head Island in 1983. On the day of its dedication, the dignitaries on hand included the entire first town council. Robert Onorato is at the microphone. (Robert Onorato.)

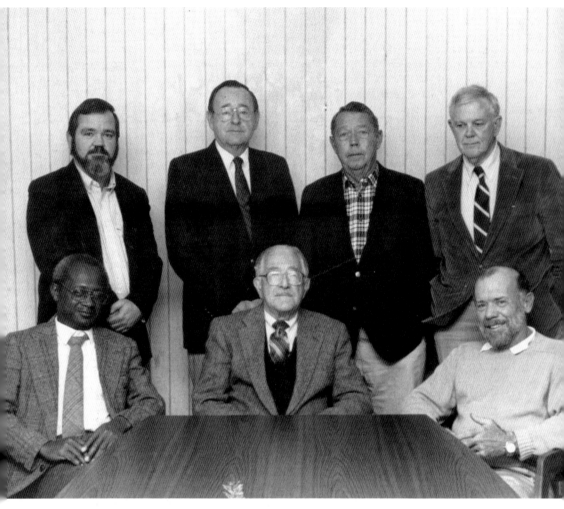

**The Barkie Council**
Pictured are, from left to right, (first row) Henry Driessen, Mayor Jerry Barkie, and S. Paul Ramsey; (second row) Tom Peeples, Fred O. Cornett, Russell L. Condit, and Frank R. Chapman. During Barkie's administration, Hilton Head Island began its first beach nourishment program with a grant from the State of South Carolina. During his administration, some citizens complained about the use of alcohol on the beach by students on spring break. A subcommittee was set up to study beachside drinking and recommended a ban on the practice. The council, on a split vote, adopted the recommendation. His council was also notable for the fact that two future mayors served with him, namely Tom Peeples and Frank Chapman. (Town of Hilton Head Island.)

### Willie "Bill" Ferguson

Not everyone was happy with the development of the Town of Hilton Head Island. Among those who watched skeptically were many of the native islanders. These were descendants of the freed slaves who were born on the island and who had lived the Gullah lifestyle in an era known as "before the bridge." Exemplifying them was Willie "Bill" Ferguson, the longest serving council member, who represented Ward One for more than 18 years. Ward One was outside of the gated communities where all the usual amenities were readily available. But in Ward One, the perception was that amenities such as paved roads and sewer service had been slow in coming. During Ferguson's service on the town council, he fought for his ward, sometimes erupting into controversy for his fiery remarks. He was not the only one to storm out of meetings, he told the *Hilton Head Monthly*, but when he did, he always received media attention. The issue of expanding the airport was a hot button for several years, and it was opposed by Ferguson. He supported the preservation of such historic areas as Mitchelville and the St. James Church. (*Hilton Head Monthly*.)

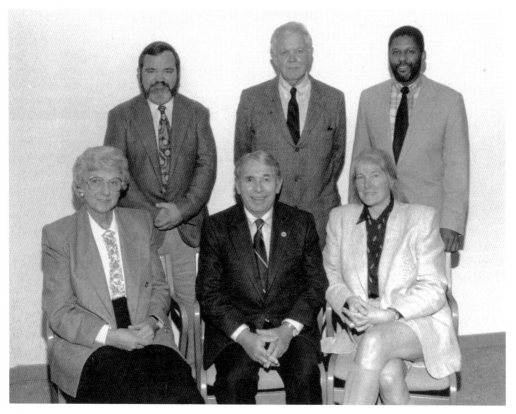

**The Chapman Council**
Pictured are, from left to right, (first row) Dorothy G. Perkins, Frank Brafman, and Kate Keep; (second row) Tom Peeples, Frank Chapman, and Willie "Bill" Ferguson. Chapman's administration may be best remembered for controversy and the mayor's habit of blunt speech. When he was elected, he promised to slow down both tourism and development. "We don't need any more money," he said. "Our tax base is fine the way it is." While he had the "burn the bridgers" on his side, many residents thought he was taking antigrowth too far. The tourism industry and local restaurants were especially critical. When the mayor complained that the area's restaurants were "too expensive and the food's bad," a local magician printed up a bunch of bumper stickers saying, "If you're Leaving Hilton Head, PLEASE take the MAYOR." (Town of Hilton Head Island.)

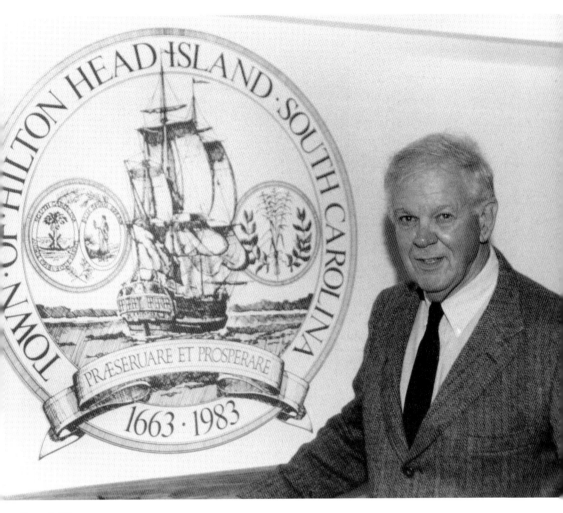

**Frank Chapman**
Frank Chapman, Yale-educated in architecture and urban planning, moved to Hilton Head in 1973, lured by its peaceful waters for his sailboat. He loved its natural beauty and opposed further growth on the island. Elected to the town council of the Town of Hilton Head Island in 1983 with the backing of the antigrowth Resident Home Owners Coalition, Chapman became mayor in 1993. His fierce opposition to tourism drew national attention when he said, in an interview with ABC News, that he was "turning over the welcome mat." He believed that tourism had destroyed property values and ruined the island's environment and way of life. Later, he said his opposition was to uncontrolled growth. Nevertheless, he remained consistent in opposition, avoiding ribbon cuttings and refusing to drive on the Cross Island Parkway, which he had opposed as a gash in the landscape. After he alienated area restaurateurs and others depending on tourism, a movement sprang up backing Tom Peeples for mayor. In 1999, still critical of the island, Chapman left Hilton Head for a home he had designed in Deer Island, Maine. (*Hilton Head Monthly.*)

### A.S. "Buzz" Carota

Late one summer afternoon, an attractive widow was walking through her condo complex carrying a tray of hors d'oeuvres for a community gathering when a red convertible, with its top down, passed her, slowed, stopped, and then backed up. The driver introduced himself as Buzz Carota, a neighbor. Later, he was to say that day was the beginning of a romance that he called "a g-d miracle."

Bobbe and Buzz Carota frequently visited Hilton Head and, like so many other visitors, eventually made it their home. His career in aviation had meant he was constantly on the go, and in Hilton Head, he was able, for the first time, to engage in civic enterprises. As president of the Residents Home Owners Coalition, he was another of those opposing growth, but over time, he became an enthusiastic reporter of the spirit of Hilton Head. He wrote a column for *Hilton Head Monthly*. He was one of the early volunteers in the formation of Volunteers in Medicine. He was at work on a book about the development of Hilton Head when he suffered a fatal heart attack. As a tribute to her husband, Bobbe Carota shepherded his manuscript through publication and still has a few copies of *The Evolution of a Town*. At left are Bobbe and Buzz Carota; below is Buzz at work. (*Hilton Head Monthly*.)

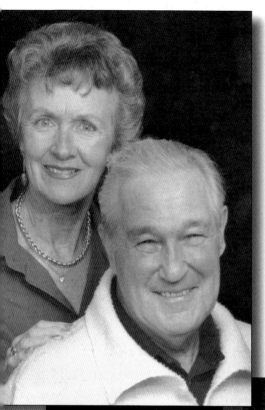

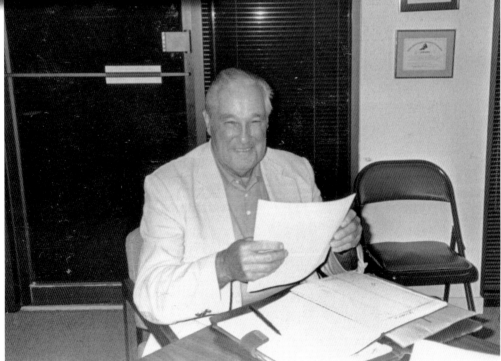

# CHAPTER EIGHT

# Building the Good Life

*Nature requires that we should be able, not only to work well, but to use leisure well.*

—Aristotle

Many of the people who came here to live, perhaps to work with Charles Fraser and share his vision or to retire, have vastly enriched the island with their own ideas and talents. Together, they established a culture of a breadth rare in a community of its size.

## Ralph Ballantine

A nationally known illustrator who created the Allstate Good Hands and the Schlitz Malt Liquor Bull, Ralph Ballantine was once himself a model, in that case for the Jolly Green Giant. He was tiring of the hectic life in the advertising world when he discovered Hilton Head and bought a lot from Charles Fraser. Soon after, he asked Fraser for a job and was put to work selling lots in Sea Pines. But his contribution to the island was to be in art. He designed his own studio from his study of Lowcountry rice barns; it was eventually to become CQ's Restaurant. For decades, he gathered regularly with other local artists at the Red Piano Gallery. He also sculpted the bust of Charles Fraser that stands by Fraser's grave at the Liberty Oak. (Island Packet.)

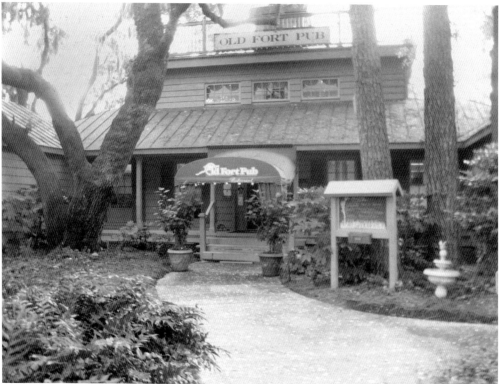

## Old Fort Pub

Ballantine designed Old Fort Pub at Fraser's request to "look like it belonged there." Fraser wanted the restaurant to sit next to Fort Mitchel and look "historical." Ballantine was able to give it that historical look, so that visitors still ask if the building is somehow associated with Fort Mitchel. The restaurant opened in 1973 and was purchased 20 years later by the Lowery Group. (Author's collection.)

CHAPTER EIGHT: BUILDING THE GOOD LIFE

### Tom Peeples, the Rawleigh Boy's Son, Becomes Mayor

Tom Peeples has the distinction of being the island's longest-serving mayor, serving for 15 years during the town's most prolific period as it evolved into a family-oriented, controlled-growth, land-protected community.

But Peeples has a longer, more intimate relationship with the island than many of today's residents. Long before the bridge, his father, Tommie Peeples, was a frequent visitor to the island with his cornucopia of just about everything needed in daily life from aspirin to clothing. Like many of the door-to-door salesmen of the era, he was known for his line of Rawleigh Products, including liniments, extracts, and spices. His youthful appearance earned him the affectionate nickname of "the Rawleigh boy." It was before the bridge, and he kept a Ford Model A on the island to make the circuit of his customers. There were, of course, no hotels, and the Benny Hudson family extended their hospitality on his regular trips.

Tommie Peeples fell in love with the island, bought a lot, built a cottage, and brought his family here so often that his son, the former mayor, does not remember a time when he did not know Hilton Head and most of its families.

And the islanders knew him as "the Rawleigh boy's son." (John Brackett Photography.)

### Coastal Discovery Museum

One of the pet projects of the Peeples family and others interested in local natural history is the Coastal Discovery Museum. A few years ago, the town purchased the old Honey Horn Plantation and converted one of the residences into a new home for the museum, which was opened in 2007. A new pavilion was constructed and dedicated to Mary Ann Peeples. The museum offers permanent exhibits as well as art shows and is a meeting place for some local groups such as the Audubon and Archaeological Societies. Here, the visitor can admire salt marshes, open fields, and centuries-old live oaks or take part in one of the many discovery programs, such as butterflies, marshes, the Gullah Geechee culture, kayaking, Marsh Tackies, dolphins, nature walks, and history at the sites owned by the Heritage Library Foundation—Zion Chapel and Fort Mitchel. (Coastal Discovery Museum.)

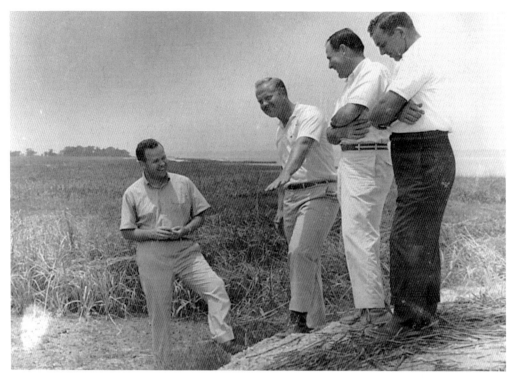

**Pete Dye, Charles Fraser, and Jack Nicklaus**
These men looked over these empty marshes and were filled with an ambitious dream; starting from nothing, they would create a world-class golf course. Charles Fraser recruited famed golf course architect Pete Dye to design Harbour Town with the assistance of Jack Nicklaus. The Heritage Classic is one of only five tournaments given "invitational" status by the PGA Tour; it usually has a field of 132 players. It was first played in 1969, when Arnold Palmer won with a score of 283, still the highest in the tournament's history. The purse has grown from $100,000 to over $5 million. Below is 2005 winner Peter Lonard (center) with Joe Fraser (left) and Angus Cotton (right). In the background is the famous candy-striped lighthouse. (Both, Sea Pines Resort.)

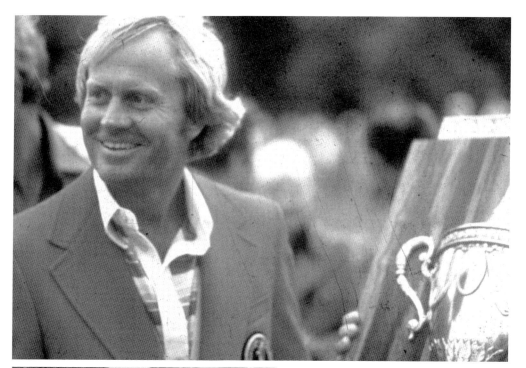

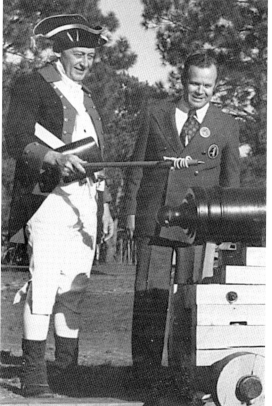

**The Heritage Classic, a Hilton Head Institution**

All other events on the island are planned around the Heritage Classic, which has not missed a year since the first tournament in 1969. Whenever it has encountered difficulties, the people of the island have rallied behind it and made sure it continued. From 1987 through 2010, it was sponsored by MCI and its eventual purchaser, Verizon. In 2011, it operated without a sponsor; the following year, it became the RCB Classic. It has developed its own traditions, like the plaid jackets based on the Fraser tartan and the cannon (left), which is fired at the opening drive. One of its most famous winners is Jack Nicklaus (above), nicknamed "the Golden Bear" and arguably the most successful professional golfer of all time, who won it in 1975 with a score of 13 under par. (Both, Sea Pines Resort.)

CHAPTER EIGHT: BUILDING THE GOOD LIFE

**The Hilton Head Symphony**
"There shall be music." It began with a small group of 14 musicians who got together to play chamber music in 1982. It grew into a full-fledged symphony with island-wide support under the leadership of Willis Shay when he appointed Gloria Daly as program director, and the Reverend John Miller incorporated space for the orchestra in the new sanctuary of the First Presbyterian Church in 1989. Performances today are usually sold out. (Hilton Head Symphony.)

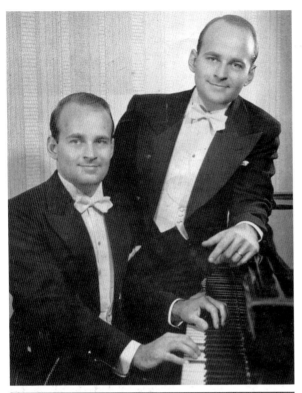

**Miles and Ernest Mauney**
They were identical twins who played piano duets to critical acclaim. One reviewer wrote that they played with "an impressive blending of warmth and brightness of tone." They toured the country with their Steinway grand pianos in a van customized for their needs until the untimely death of Ernest in 1959. (Phyllis Mauney.)

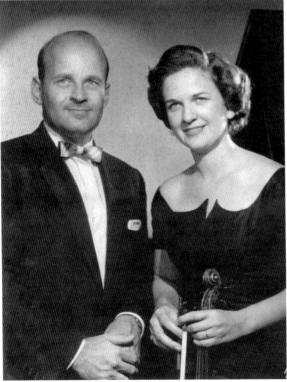

**Miles and Dorothy Mauney**
Miles Mauney taught at several schools until he and his wife, Dorothy, a violin virtuoso, moved to Hilton Head in 1984. Here, they performed as the Mauney Duo, taught music, and are credited with being a guiding inspiration for the symphony orchestra. (Phyllis Mauney.)

**Phyllis Mauney**
The daughter of Dorothy and Miles Mauney, she has probably played the harp for more American presidents that anyone else. With the "President's Own" Marine band, she played in the Carter, Reagan, George H.W. Bush, and Clinton White Houses. She played "Danny Boy" for Bill Clinton, who accompanied her. She also played at a White House engagement party for Prince Charles and Princess Diana. No longer in the Marines, she plays with the Hilton Head Choral Society, directed by Tim Reynolds. (Phyllis Mauney.)

**Willis Shay** (OPPOSITE PAGE)
Among many island innovations in which Willis Shay has been involved, he takes much pride in the International Piano Competition (IPC), which he began in 1996 and chaired for nine years. Among many such men who have graced the island, he was to Buzz Carota, author of *The Evolution of a Town*, the consummate Renaissance man. Here, Shay is at a reception at Carnegie Hall, introducing a winner of the IPC, Edisher Savitski from the Republic of Georgia, one of whose prizes was to play at the hall.

The competition fulfills the following two important parts of the orchestra's mission as Shay envisioned it: to encourage young people in their musical careers and to present the residents and visitors of Hilton Head Island with quality music. (Willis Shay.)

**Gloria Daly**
It was said by many people that, when Willis Shay was president of the Hilton Head Symphony Orchestra, his smartest decision was to recruit Gloria Daly to the symphony, where she has served as general manager, executive director, and program director. She has been involved in everything the symphony does ever since. In addition to serving on the orchestra's board, she has headed up the United Way residential campaign and the Hope Haven Board. In 2010, she received the Alice Glenn Doughtie Good Citizenship Award given by the Hilton Head Island–Bluffton Chamber of Commerce. She is shown (center) with John and Valerie Curry (see Page 92). (Gloria Daly.)

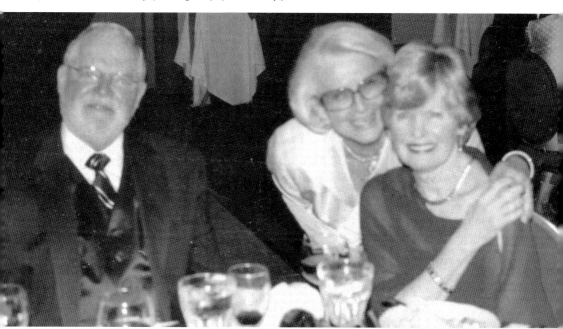

### The Greers

Walter Greer is fond of saying, "If it hadn't been raining that day in Savannah. . . ." He and another artist were scheduled to paint on a marina that day in 1960, but rain spoiled their plans. He remembered that a friend, knowing his love for nature, had recommended a visit to Hilton Head.

That visit was the beginning of what would be an epochal romance for him and for the island. As he drove on unpaved roads under the massive branches of live oak, he recalled, "I knew I wanted to see Spanish moss for the rest of my life." That very day he bought a lot on the island.

And here, he met the writer Margaret Orr, and the Greers became an iconic couple of the arts. Their years together have been imbued with fun and experiments in ways to capture the island—Walter created diaphanous paintings of ponds and sensitive paintings of Gullah people and their homes, and Margaret wrote of the island's history and in exquisite prose a celebration of the senses in *Discovering Hilton Head: A View of Nature's Wonders*. Obvious in both their works is a palpable love of the island with an underlying joy. Margaret also wrote a history of the island, *The Sands of Time*, and a history of the Hilton Head Symphony Orchestra, *Making Music*. Her books are now collector's items. They are shown with their Cavalier King Charles spaniels, Prince and Beau. (Greer family.)

CHAPTER EIGHT: BUILDING THE GOOD LIFE

**Walter Greer at Work on a Folding Screen** Walter Greer's paintings are highly individualistic, adopting the technique best suited to that which he wanted to express. Throughout all his art runs his love of nature; he said of *Shell Ring*, "[It] expresses the idea of regeneration, the persistence of man's relationship to nature." His paintings are also highly prized, now hanging in galleries and private homes around the world. This screen is one of Walter Greer's most notable works, especially commissioned by a patron. With him is his cocker spaniel Ruffles. (Greer family.)

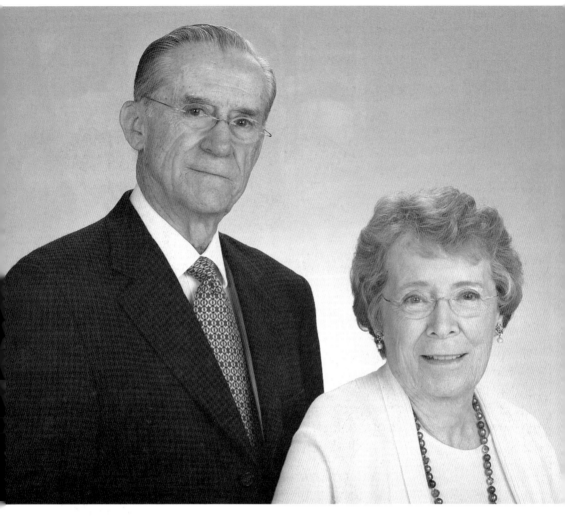

**Willis and Doris Shay**

Both Willis and Doris Shay have been active in the Hilton Head arts community since they arrived here in 1981. In fact, the existence of such a community was one of the reasons they chose to retire here. Willis Shay has been key to the success of the local symphony orchestra and the International Piano Competition. His walled Japanese garden is locally famous. He has also been very active in such civic matters as studies for growth management and for the future of the island. He has twice been recipient of the Volunteer of the Year Award.

He met the woman who would be his wife at a function in West Virginia. When he called her one night to ask her out, her mother answered the phone and called Doris. Doris replied, "Oh, it's too late." Her mother protested, "Oh, but he has such a nice voice!" Indeed, Willis Shay has since been an announcer for an NPR classical music station in Savannah and a vocal soloist for the Savannah Symphony.

Doris Shay is known for her painting, especially her vibrant watercolors. When the Art League opened its first gallery in Sea Pines, she was a featured artist for one of their first solo shows. Over the years, Doris has had many one-woman shows and chaired the Art League's first juried show. (Shay family.)

**Walter Greer Gallery**
The Arts Center of Coastal Carolina (formerly the Self Family Arts Center) named its art exhibition gallery in honor of Walter Greer. The center was built on land donated by the Greenwood Development Corporation, also the developer of Palmetto Dunes. (Author's collection.)

**Reception for the Greers**
Margaret and Walter Greer greet art lovers at the opening of the Walter Greer Gallery in 1996. (Arts Center of Coastal Carolina.)

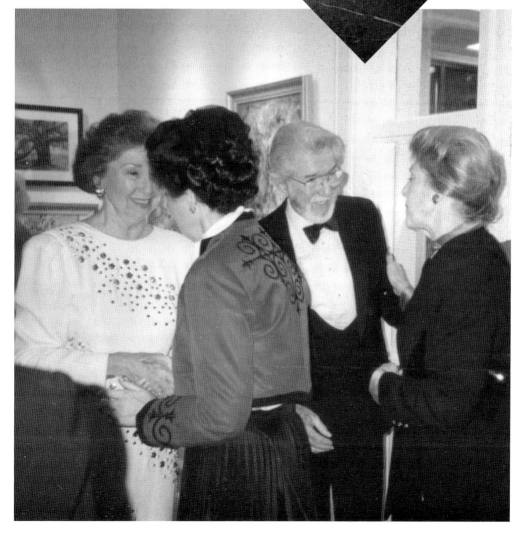

### John and Valerie Curry

They were the consummate couple who loved the island; both worked for its culture and success. They came to Hilton Head in 1973 when John joined Sea Pines Company as executive vice president. He soon became involved in community activism and was one of the leading spirits for the incorporation of the Town of Hilton Head Island. He felt it important that Hilton Head should be able to have its own zoning regulations and laws. He also worked hard for tourism as chairman of the South Carolina State Hotel and Motel Association and, for 17 years, led the Hilton Head Chamber of Commerce's Visitor and Convention Bureau. He is credited with saving the Heritage Classic and planned communities from bankruptcy. His awards included the Alice Glenn Doughtie Citizen of the Year, the Order of the Palmetto from the governor of South Carolina, and the Fred Brinkman Award at the South Carolina Governor's Conference on Tourism and Travel.

Valerie Curry was an ardent supporter of Hilton Head. Remembering "Val," David Lauderdale of the *Island Packet* said, "She wove beauty into our lives." As the founding director and chairwoman of the committee that formed the Hilton Head International Piano Competition, Lauderdale wrote, "She set the tone that it would be well-organized and have dignity, but most of all show warmth and hospitality to the contestants and judges."

The couple is remembered by the Hilton Head Island Wine and Food Festival in the form of gifts to the John and Valerie Curry scholarship fund. (Curry family.)

**Governor West**

Called a "crusading governor" by the New York Times, John C. West lived in Hilton Head and became governor of South Carolina in 1971. Practically his first action as governor was to vow to rid the state government of "any vestige of discrimination" and make it colorblind. One of his senior aides was James Clyburn, who, the Times noted, was the first man of color to serve in the inner circle of a governor. Today, Clyburn is a representative for South Carolina in the US Congress, serving since 1993.

Governor West (center) is pictured with his wife, Lois, and the Hilton Head Island entrepreneur Robert Onorato. (Robert Onorato.)

### Joe Fraser

Joe Fraser came to Hilton Head Island in the early 1950s to manage his father's sawmill. In the 1960s, he became the first president of Sea Pines Homebuilders, and later, he served as president of planning, design, and construction and president of Sea Pines Plantation Company. He was to lead the development of some of the most acclaimed residential and resort communities on the continent, including Sea Pines Plantation, Hilton Head Plantation, Amelia Island Plantation, and Kiawah Island.

He and his group were known for pioneering architecture and communities that blended with the environment, for conservation-minded construction, and for the protection of wildlife preserves and green space. He is also widely credited with saving the Heritage golf tournament in the late 1980s, setting up a foundation that was to help support many important local nonprofits. (*Hilton Head Monthly*.)

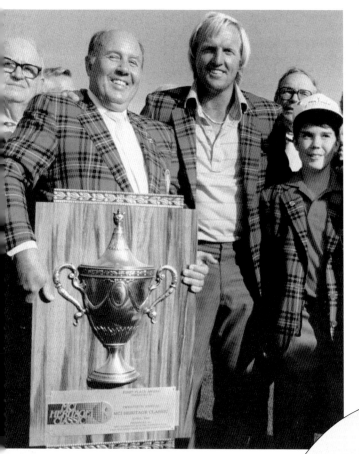

### Fraser Family Portrait
Joe Fraser is the taller one in the back. Charles Fraser, his younger brother, is on the left, next to his mother. (*Hilton Head Monthly*.)

CHAPTER EIGHT: BUILDING THE GOOD LIFE

**Billie Jean King**
The Family Circle Cup, a Women's Tennis Association–affiliated professional tennis tournament for women, began in 1973 at Sea Pines on Hilton Head Island and was played there every year until it moved to Charleston in 2001. Billie Jean King played here in 1977, where she was the runner-up, losing to Chris Evert. But like many other athletes, Billie Jean King's enjoyment of Hilton Head's amenities was not limited to tennis; here she is shown on one of Palmetto Dunes' golf courses with entrepreneur Robert Onorato. (Robert Onorato.)

### Johnny Miller

Johnny Miller won the Sea Pines Heritage Classic in 1973 and again in 1974. Famous in later years for his blunt call-'em-like-you-see-'em broadcasting style, he was an exceptional golfer in his prime. The World Golf Hall of Fame says the following of him: "In golf's modern era, it's commonly understood that no player has ever achieved the brief but memorable brilliance of Johnny Miller. . . . [In 1974–1975] Miller hit the ball consistently closer to the flag than any player in history. At his best, Miller's game was marked by incredibly aggressive and equally accurate iron play."

In 1972, hired at the age of 25 as touring pro for Palmetto Dunes on Hilton Head, Miller won the Heritage Classic, and he won it again in 1976. (Robert Onorato.)

### Don Peterson

Don Peterson was originally from Iowa and worked for several years for DeLoitte & Touche CPAs in Chicago and Atlanta. Charles Fraser, with his usual skill in finding people to help in development of Sea Pines, recruited Peterson in 1965 to serve as his chief financial officer. There, he assisted in securing major funding for Sea Pines' expansion, including the golf course, lot development, and the planning and building of Harbour Town.

Following his three-year stint with Sea Pines, he entered into a joint venture and, with several partners, developed condominium projects on Hilton Head Island, primarily in South Forest Beach. Later, he formed the D.C. Peterson Company for real estate sales and Seashore Vacations to handle vacation rentals.

He is still active in real estate and was honored in 2012 with a 40-Year Award as a founding member of the Hilton Head Board of Realtors, where he served a year as president. He also served for 25 years as member and chairman of the Forest Beach Sewer, Water, and Fire District Commission. (Don Peterson.)

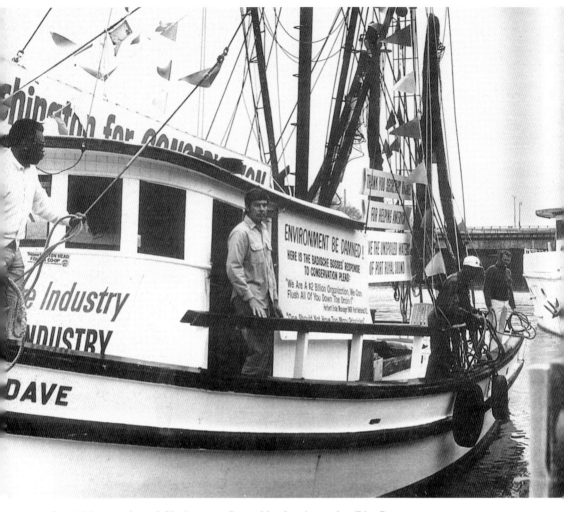

### David Jones, Local Shrimper, Goes Up Against the Big Guys

David Jones was, according to the *Island Packet*, for over 60 years the busiest man on Hilton Head. He owned a garage and three shrimp boats, was president of the Hilton Head Fishing Cooperative, and was captain of the local volunteer firefighters. His most spectacular achievement may have been his protest against a huge global corporation.

In the late 1960s, the German chemical firm Badische Anilin und Soda Fabrik (BASF) announced plans to put a chemical plant on the waters just off Hilton Head. Local developers and fishermen alike were united in their opposition to the plant, which would be dumping tons of effluent into the pristine waters.

It was David Jones who organized a dramatic ploy against BASF involving Walter Hickel, then secretary of the interior. Jones had one of his fleet, the *Captain Dave*, deliver a petition with 30,000 signatures, plus a boatload of fresh shrimp, to a dock in Washington. There, Secretary Hickel, a flood of reporters, and a convoy of Secret Service met him. BASF eventually dropped the project. The area in question is now the site of Waddell Mariculture, a center that studies how to protect and manage natural resources. (David Jones.)

### Karena Brock-Carlyle

The Hilton Head Dance Theatre is the creation of its artistic directors Karena Brock-Carlyle and her husband, John Carlyle. Karena was named a principal dancer with the American Ballet Theatre (ABT) during its golden era; she shared the stage at Lincoln Center with such notables as Mikhail Baryshnikov, Rudolf Nureyev, Natalia Makarova, Cynthia Gregory, and Carla Fracci. After 15 years with the ABT, Karena became artistic director of the Savannah Ballet. John studied at the Harkness School of Ballet and danced professionally with City Center Dance Theatre in Atlanta, the Tampa Ballet, and the Savannah Ballet. In 1985, the couple moved to Hilton Head and opened the Hilton Head Dance School. The school has grown to an enrollment of approximately 250 today. With the school established, the Hilton Head Dance Theatre was formed as a nonprofit entity with the mission of fostering an appreciation of dance as an art form in the Lowcountry. (Hilton Head Dance Theatre.)

**Stan Smith** (OPPOSITE PAGE)
Stanley Roger "Stan" Smith's tennis prowess is legendary. He won the Masters Grand Prix in 1970, the 1971 US Open (against Jan Kodeš), and 1972 Wimbledon (against Ilie Nastase). In 1972, he was the year-ending World No. 1 singles player. In 1973, he won the championship title at the Dallas WCT Finals. He also won four Grand Prix Championship Series titles. With his wife and four children, he lives on Hilton Head and is co-owner of the very successful Smith Stearns tennis academy. He is active in the Heritage Classic Foundation, which sponsors the annual golf tournament of that name.

He was inducted into the International Tennis Hall of Fame in 1979. His listing there reads as follows: "One of the great sportsmen of tennis, a man who commanded respect for both the caliber of his game and the strength of his character, Stan Smith was an authentic American hero of the early Open Era. Tall and stately at six feet, four inches, he conducted his business on the court with quiet but unmistakable conviction. With his strong moral fiber and rectitude, he represented his country with almost unparalleled dignity and honor in Davis Cup competition." (Stan Smith.)

**Bill Marscher**
William F. "Bill" Marscher was born in nearby Beaufort, attended Princeton, worked on the Apollo moon mission, and came back to Hilton Head to work for Charles Fraser at Sea Pines. When 500 acres of shellfish waters in southern Beaufort County were closed due to pollution in 1995, Marscher became the de facto head of the Clean Water Task Force. Its landmark 1997 "Blueprint for Clean Water" resulted in a number of scientific, regulatory, and private moves to protect the rivers.

He also served on the boards of several regional environmental groups and cowrote two books with his wife, Fran Heyward Marscher, *The Great Island Storm of 1893* and *Living in the Danger Zone: Realities about Hurricanes*. (Hilton Head Monthly.)

### Natalie Hefter

Natalie Hefter tells a group of schoolchildren about the history of the Baynard Mausoleum in the cemetery of the colonial-era Zion Chapel of Ease. As the vice president of programs for the Coastal Discovery Museum, Hefter manages the education and exhibit segments of the museum's programs, including its recent permanent exhibit installations at historic Honey Horn. She came to the museum in 1997 and, in 1998, assembled nearly 200 photographs for Arcadia Publishing's Images of America: *Hilton Head*. She is a 2002 graduate of the Hilton Head Island–Bluffton Chamber of Commerce's leadership program and currently serves on its board of regents. She also served as cochair of the chamber of commerce's arts and culture committee and on the advisory board for the Heritage Library Foundation. (Coastal Discovery Museum.)

CHAPTER EIGHT: BUILDING THE GOOD LIFE

**Civil War Sesquicentennial at Honey Horn, Doctor**
Representing a typical doctor of the period was Davis Tooms with hair-raising stories of the era's medical practices. (Author's collection.)

**Civil War Sesquicentennial at Honey Horn, Photographer**
Professional area photographer Bob Beine showed off his vintage photographic equipment. He also took photographs of visitors using Civil War props but with a modern digital camera. (Author's collection.)

**Civil War Sesquicentennial at Honey Horn, Cannoneers**
The 22nd Georgia Heavy Artillery was represented by, from left to right, Buddy Jones, Howard Williams, and James Moore. (Author's collection.)

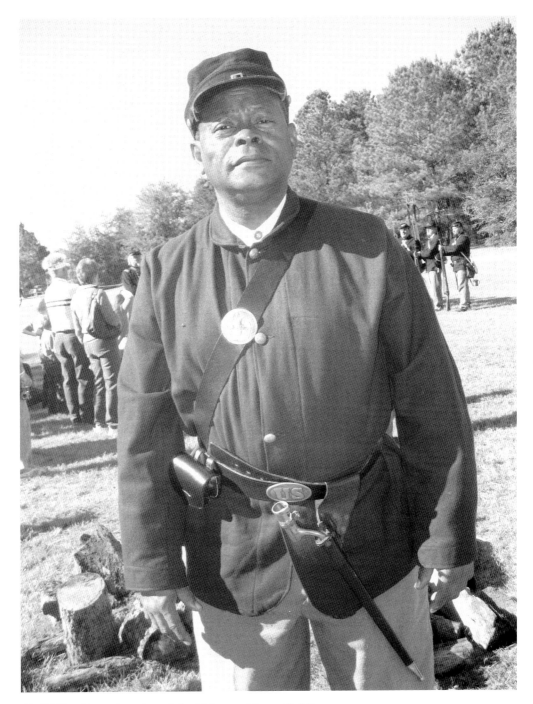

**Civil War Sesquicentennial at Honey Horn, Soldier**
Bernard George represented the Union as a member of the 1st North Carolina Colored Volunteers. (Author's collection.)

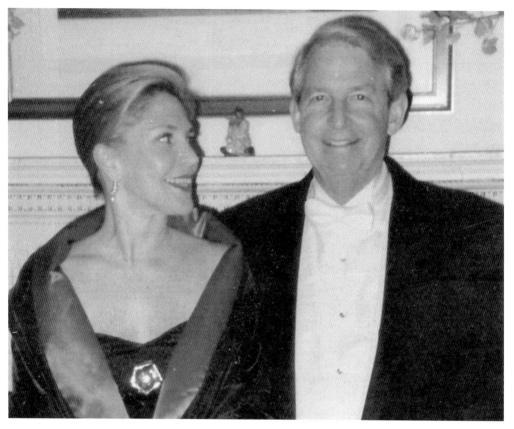

**Berry and Ruthie Edwards**

On an October weekend in 1973, Berry and Ruthie Edwards visited Hilton Head and promptly fell in love with the place. At the time, the island had no hospital, and there were few places to buy groceries. They had two young sons and were dubious about the schools. Yet they were intrigued with the possibilities they could see on the island. They bought a landscaping business, renamed it The Greenery, barged an old church to the island as headquarters, and never looked back. They started with six employees; today, The Greenery employs 500 and serves most of the area surrounding Hilton Head.

Berry has always been active in the community, serving on the board of the Coastal Conservation League and as a member of the original planning commission, a member of the boards of the chamber of commerce and the Community Foundation of the Lowcountry, and board chair of Volunteers in Medicine. Ruthie owns Ruth Edwards Antiques and Interiors and has been one of the leaders in just about every important gala or fundraiser on the island. They believe in giving back; Berry told the *Island Packet*, "We should give back. It's an obligation." (Edwards family.)

CHAPTER EIGHT: BUILDING THE GOOD LIFE

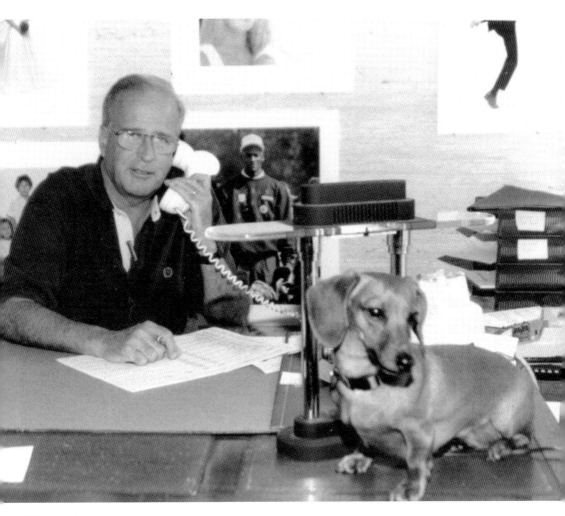

**Bill Littel**
Bill Littel is another legend of Hilton Head, having been a part of and photographed just about every event of significance on the island for the past 40 years. Here, he is shown with his dog Katie. His professional work includes studies of children, wildlife, and pets, and he is much in demand as a wedding photographer. (*Hilton Head Monthly.*)

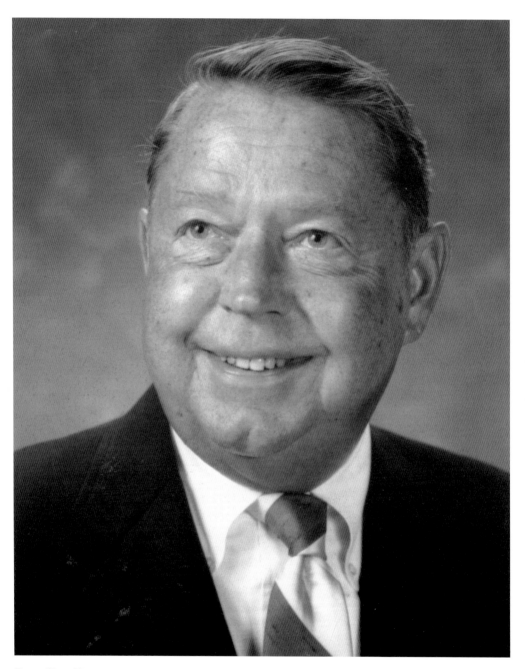

**Russ Condit**
Russell Condit retired to Hilton Head in 1985 after spending 37 years with Proctor and Gamble, the last 22 as advertising director. Like so many others, he plunged into public service, serving three terms on the council and five years on the Hilton Head Foundation Board.

Mayor Tom Peeples said the following of Condit: "[He] was the kind of councilman who did serious homework on issues. His constituents could always count on Condit to attend their property owners associations meetings and stay in touch with community concerns. He was just a genuinely nice man that worked really hard for his town." (*Hilton Head Monthly*.)

CHAPTER EIGHT: BUILDING THE GOOD LIFE

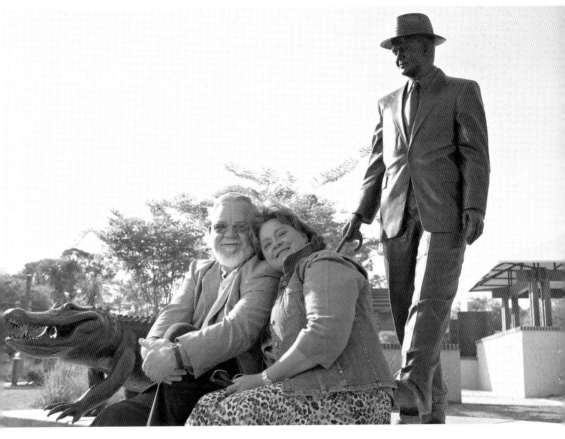

**Tom and Mary Ann Peeples**
Tom Peeples was mayor of the Town of Hilton Head from 1995 to 2010, overseeing an explosion of parks, pedestrian walkways, and bike paths. He and his wife, Mary Ann, have long been active in civic affairs. Mary Ann serves on the board of Caring Coins, a foundation established by Hargray, the island's first communication provider. She and Tom have been active supporters of the Coastal Discovery Museum, and the pavilion there was named in her honor. Both grew up in a nearby town, and though they have known each other most of their lives, she told *Pink Magazine*, "We're still not only in love, but we are best friends."

Here, they are shown at the Compass Rose Park by the sculptures of Charles Fraser and the alligator. (Bill Littel.)

**James N. "JR" Richardson**
When he went to work for Charles Fraser at Sea Pines, he was one of several Jameses at the company; he quickly became know as "JR," and the name has stuck ever since. He took over the family business at Coligny Plaza and created Westbury Park and Windmill Harbor. He has been recognized for his development and passion for saving trees and creating beautiful communities for today and the next generations.

JR served on two volunteer committees, the Mayor's Task Force for the Future of Hilton Head and the Sea Pines Strategic Planning for the Future Committee. He is sought after for his vision and is generous with his time and energies in the community, serving on multiple boards and commissions. Among them are the following: the Hilton Head Island Foundation; South Island Public Service Commission; Community Foundation Public Art Committee; MUSC Foundation Board; Sea Pines Plantation Architectural Review Board; South Carolina Yacht Club Board; Hilton Head Island Board of Realtors; the Wine Auction to Benefit Arts Center; and the Town of Hilton Head Design Review Committee. (Richardson family.)

# CHAPTER NINE

# Giving Back

*You must give some time to your fellow men. Even if it's a little thing, do something for others—something for which you get no pay but the privilege of doing it.*

—Albert Schweitzer

The people in the following pages (as well as in some of the preceding pages) adhered to Schweitzer's advice, thus contributing to the growth, culture, and sense of community that characterizes the town of Hilton Head Island, even when disputes arise. The common bond that holds together many of the legendary locals of Hilton Head is their strong belief in giving back.

**David Lauderdale**
David Lauderdale has become a fixture on Hilton Head. Many subscribers to the daily paper, the *Island Packet*, turn first to his column, which may deal with some aspect of island lore, a local personality, his own musings, or stories sent by his readers. He has written nearly a thousand columns and is much in demand as a local speaker for his extensive knowledge of the island. He also holds a popular Sunday school class at the First Presbyterian Church where, he says, he usually considers some timely event and makes scriptural connections to it. (*Island Packet*.)

**Tom Senf and Norman Harberger**

Tom Senf (left) was in Hilton Head only a few short years, moving here in 2006, but he made an impact on the island before succumbing to a mysterious autoimmune problem in 2012. Long one of the nation's top printing salesmen, he brought his abilities and talents to the island, concentrating on the annual Hilton Head/Savannah Equestrian Exposition instituted by Dr. Sandy Termotto. The exposition has raised over $200,000 to benefit local charities.

Norman Harberger has been such a key member of the development of Hilton Head over the years that he is in demand for talks about the Fraser years. That was when the island woke up and said hello to the world. The boards that have benefited from his wit and wisdom include the Heritage Classic, the Children's Center, the Heritage Library, Sea Pines, the Technical College of the Lowcountry, and Seacoast Synergy. (Author's collection.)

**Charlotte Heinrich**
Heinrich, shortly after she came to Hilton Head in 1968, began working with local doctors on local health problems. A nurse with a master's degree in public health, she recognized that many children on the island were suffering from the contamination of the local shallow wells, and the Deep Well project was begun. It was a one-woman campaign to provide deeper, safer wells. Deep Well has become an island social service organization, providing food for the hungry, temporary shelter for the homeless, assistance with utility bills, medicine, and other urgent needs. She regularly drove those without cars to Beaufort to collect food stamps, was involved with Volunteers in Medicine and the Bargain Box, and helped found the Island Rescue Squad. (*Island Packet.*)

## Billie Hack

Billie Hack was much beloved. Besides being the first president of the Women's Association of Hilton Head Island, a founding director of the Children's Center of Hilton Head Island, and a cofounder of the Friends of the Library, in 1965, she was one of the founders of the Bargain Box, a charitable resale operation. It was begun in 1966 to raise money for the First Presbyterian Church but soon became one of the island's most important sources of support for the island's nonprofits. (Frederick Hack.)

**Cartha "Deke" DeLoach**
DeLoach spent 28 years at the FBI (the last five as second in command to J. Edgar Hoover) and a stint as a chief executive of Pepsico. He was a close friend of the Frasers, who gave him a tour of Hilton Head in 1971. DeLoach fell in love with the island, bought a lot the next day, and moved here permanently in 1980. Shortly thereafter, he ran for the town council and won in a landslide. While there, he was able to obtain an old DC-3 for the island's mosquito control program.

There had always been a strong interest in the arts on the island, and in 1986, Helen Racusin, then president of the Hilton Head Island Cultural Council, asked DeLoach to create an arts center for the town. The disparate arts groups and some of the residents were skeptical of the idea, but many people worked together to overcome their reservations. In 1996, the Self Family Arts Center, built on land donated by the Self family, opened in a 44,000-square-foot facility with a 3,600-seat theater and a 2,300-square-foot art gallery. Buzz Carota wrote, "Many people were involved in the dream project, but it was DeLoach's leadership and unswerving determination that made it happen." (Cartha DeLoach.)

CHAPTER NINE: GIVING BACK

**David Ames**
David Ames has helped make Hilton Head Island. He came here in 1973 to help with the development of Sea Pines, not expecting to stay. But he did stay and became, according to David Lauderdale, "a voice of reason." Lauderdale goes on to state, "I say 'reason' because he wanted the community to succeed economically, aesthetically and, most importantly, as a place to call home and rear children." He serves on the boards of the Children's Center and Hope Haven. This photograph is from the opening of the Isaac Wilborn Children's Center's new building (David Ames.)

LEGENDARY LOCALS

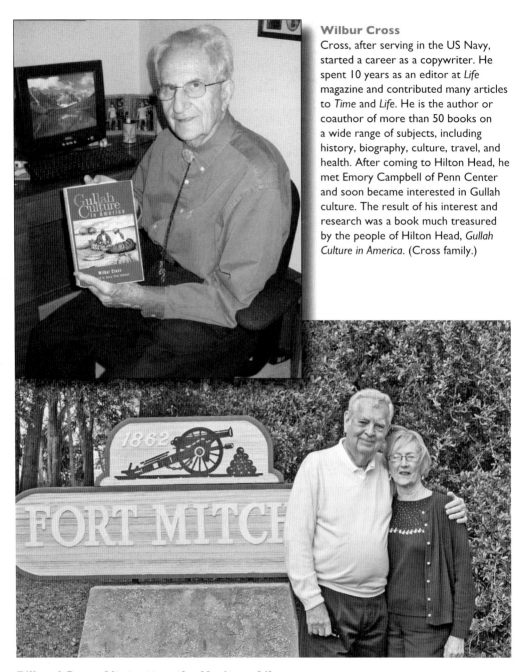

**Wilbur Cross**
Cross, after serving in the US Navy, started a career as a copywriter. He spent 10 years as an editor at *Life* magazine and contributed many articles to *Time* and *Life*. He is the author or coauthor of more than 50 books on a wide range of subjects, including history, biography, culture, travel, and health. After coming to Hilton Head, he met Emory Campbell of Penn Center and soon became interested in Gullah culture. The result of his interest and research was a book much treasured by the people of Hilton Head, *Gullah Culture in America*. (Cross family.)

**Bill and Gwen Altstaetter, the Heritage Library**
The Altstaetters were among the founders of the Heritage Library Foundation, established in 1997, and the two have been guiding spirits of it ever since. The foundation absorbed the Historical Society of Hilton Head Island in 2005 and is the island's principal resource center both for historians and genealogists today. It schedules regular lectures on history (not limited to Hilton Head) and classes in genealogical research. Staffed entirely by volunteers and open four days a week, the library fields hundreds of questions a month. The Altstaetters are shown at Fort Mitchel, a historic property owned by the foundation. (Carol Clemens.)

### Bill Bligen, Adult Literacy Student and Activist

Bill Bligen was born on Hilton Head in the heart of the Gullah community. As a child, he was shunted around by relatives and was never in one place long enough to get any real schooling. He reached adulthood not knowing how to read but was eventually able to find good-paying work in the construction business in New York. He saved his money, returned to Hilton Head, built a house, and in his late 60s decided it was time to learn to read. With the help of the Literacy Volunteers of the Lowcountry, he opened the doors to a whole new world. With his newfound literacy, he became an activist and wrote letters to state officials (and even the president of the United States) championing the cause of literacy. Before he died, with the help of Lore Krieger, he wrote a first-person account of his life called *Road Out of Darkness: Life of Bill Bligen*. The Literacy Volunteers of the Lowcountry have helped distribute the book as an inspiration to others taking up literacy as adults. Bligen became a sort of unofficial mascot for the Literacy Volunteers of the Lowcountry and is now remembered by their annual Bill Bligen Champion of Literacy Award. (Both, Literacy Volunteers of the Lowcountry.)

**Dorothy Anderson**

When Dorothy Anderson retired from a lifelong career in education (teacher and principal) to Hilton Head in 1978, she had long been active in the American Association of University Women. She joined the local chapter and discovered their project was Literacy Volunteers of the Lowcountry, an organization devoted to ending illiteracy. It was a cause dear to her heart, and she plunged in, helping the volunteers find an office on the island (they started in the First Presbyterian Church) and finding volunteer tutors. She served as president and later as chairwoman of the board. Now living at the Seabrook retirement home, she holds costume jewelry sales there several times a year to benefit the Literacy Volunteers. She also has served as chairwoman of the board of trustees at Seabrook and stays busy with bridge, mah-jongg, a gardening club, an herb society, and the National Audubon Society.

But her true love still is education. "She continues to be a strong force in the community with her involvement in the American Association of University Women and Literacy Volunteers of the Lowcountry," according to the *Island Packet*.

The Literacy Volunteers of the Lowcountry began to emphasize its adult literacy programs in the 1980s, helping hundreds of people improve their reading, writing, math, and English skills. They also teach Citizen Preparation, responding to a growing need in the community. (Dodi Eschenbach for Literacy Volunteers of the Lowcountry.)

### Dr. Jack McConnell with Dr. Richard Baylord

"What have you done for someone today?" This phrase so often used by Dr. Jack McConnell was from his dinner table as a child, when his father routinely posed the question. Jack McConnell became a doctor, worked at McNeil Laboratories, and helped to develop Tylenol and the MRI. After retiring and moving to Hilton Head, he was enjoying golfing but gave it up when he realized an unmet medical need. Here on the island of the affluent were people who simply could not afford medical care. So Volunteers in Medicine (VIM) was born and has since spread across the nation, with 80 VIM clinics operating and many more planned. The national organization now gives the Jack B. McConnell Award for Volunteerism. In 2009, it went to Dr. Richard Baylord of Kilmarnock, Virginia, shown here with Dr. Jack McConnell (right). Islanders consider Jack McConnell the exemplar of giving back. (Volunteers in Medicine.)

**Bob Masteller**
Bob Masteller is another find brought to Hilton Head by Charles Fraser in 1973 as vice president for human resources. He is perhaps best known for his legendary Jazz Corner, which he opened in 1998 and which remains extraordinarily popular today. In 2010, *Downbeat* magazine named it one of the top 150 clubs in the world. Recently, it received the coveted Trip Advisor Certificate of Excellence. It also received first place in the 2011 Culinary Showcase at the International Eco-Tourism Conference.

Perhaps less well known is Masteller's sterling history of civic involvement in a wide variety of activities benefiting Hilton Head Island, including the arts, politics, business relations, health services, and education. In 2004, he established the Junior Jazz Foundation. In 2011, the foundation inaugurated a Jazz Camp, which teaches American youngsters from all across the country the significance and intricacies of this thoroughly American music. Masteller was also involved in the establishment of the Town of Hilton Head Island, serving on the search committee for the city manager and drafting the job descriptions for the mayor and the city manager. He has played at benefits for the Hilton Head Hospital, the Boys and Girls Club, Zonta, United Way, Rotary, Deep Well, and many other nonprofit organizations. (Masteller family.)

## Isaac Wilborn

"Every community deserves a leader like Isaac Wilborn," said the South Carolina Black Hall of Fame when inducting Isaac Wilborn. He is a retired AME pastor.

Back in the 1950s, then principal of the elementary school, he noticed that some of the children were missing school to care for their younger siblings. Then as now, child care was one of the biggest problems for working families. Billie Hack, a founder of the Bargain Box, enlisted civic groups, builders, parents, and children to build a nonprofit day care center that welcomed 15 children when it opened in a simple one-room building. In 2010, Wilborn was honored at an open house in the brand-new Children's Center, a 19,000-square-foot, $5-million facility.

Wilborn served on the boards of the Hilton Head Regional Medical Center and the Palmetto Electric Cooperative. His other community affiliations have included president of Beaufort County Education Association, member of the Beaufort County Higher Education Commission, chairman of the Beaufort-Jasper Mental Health Association, president of Hilton Head Island Human Relations Council, vice president of the Hilton Head Island Community Association, member of the Lowcountry Resource Conservation and Development Advisory Committee, trustee of Hilton Head Hospital, and chairman of the board of directors of Communities in School.

With Charles Fraser, he set up Easter sunrise services in 1957 at Coligny Circle. Lois Richardson recalled that a pastor from Ridgeland came over with a piano strapped onto a flatbed truck. "It's something very special," she said, "when you watch that sun come up over the water." (*Island Packet.*)

## The Blue Lady

Perhaps the most poignant ghost story of the island is that of the Blue Lady. During a three-day period in 1898, as hurricane winds howled about the Leamington Lighthouse on Hilton Head, 20-year-old Caroline Fripp and her father, Adam Fripp, the lighthouse keeper, struggled in the lantern room to keep the light burning to aid navigation during the storm. According to one story, Adam was felled by a massive heart attack at the very moment that the winds penetrated the lighthouse and blew out the lamp. Following her father's wishes, Caroline tended the light for the next few days. Exhausted by the work and her grief, Caroline died three weeks later. Since then, she has been reported around the lighthouse, sobbing, and wearing the blue dress she wore during her ordeal. It has also been reported that a couple driving through a storm in the area picked up a soaking wet young woman in a blue dress who climbed into the back seat. Later, they looked back to see the seat empty except for a puddle of water. (CQ's.)

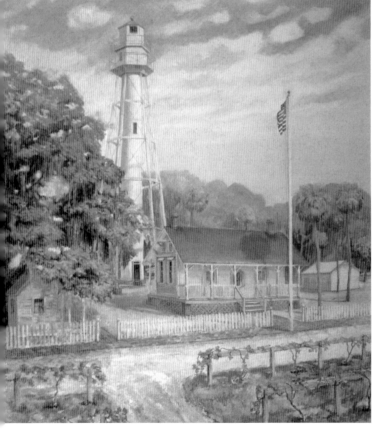

**Leamington Lighthouse**
This painting of the Leamington Lighthouse by famed local artist Walter Greer hangs in the home of Patricia and Robert Onorato. (Patricia and Robert Onorato.)

# BIBLIOGRAPHY

Bligen, Bill and Lore Krieger. *Road Out of Darkness: Life of Bill Bligen*. Privately published, 2004.
Carota, Buzz. *The Evolution of a Town: Hilton Head Island, South Carolina*. Auburn Hills, MI: Data Reproductions Corporation, 2002.
Carse, Robert. *Department of the South: Hilton Head Island in the Civil War*. Hilton Head Island, SC: Heritage Library Foundation, 2000.
Cuthbert, Robert B. *Northern Money, Southern Land: The Lowcountry Plantation Sketches of Chlotilde R. Martin*. Columbia: University of South Carolina Press, 2009.
Danielson, Michael N. *Profits and Politics in Paradise: The Development of Hilton Head Island*. Columbia: University of South Carolina Press, 1995.
Greer, Margaret. *Discovering Hilton Head Island: A View of Nature's Wonders*. Hilton Head Island, SC: SouthArt, 1987.
———. *Short and Tall Tales of Hilton Head Island*. Altona, MB: D.W. Friesen, 2004.
———. *The Sands of Time: A History of Hilton Head Island*. Hilton Head Island, SC: SouthArt, 1994.
Holmgren, Virginia C. *Hilton Head: A Sea Island Chronicle*. Hilton Head Island, SC: Hilton Head Publishing Co., 1959.
Marscher, Fran Heyward. *Remembering the Way It Was: At Hilton Head, Bluffton, and Daufuskie*. Charleston, SC: History Press, 2005.
———. *Remembering the Way It Was: At Hilton Head, Bluffton, and Daufuskie Vol. II*. Charleston, SC: History Press, 2007.
McCracken, Charles C. *The Forgotten History: A Photographic Essay on Civil War Hilton Head Island*. Hilton Head Island, SC: Time Again Publications, 1993.
Rankin, Richard. *A New South Hunt Club: An Illustrated History of the Hilton Head Agricultural Society, 1917–1967*. Winston-Salem, NC: John F. Blair, 2006.
Rhyne, Nancy. *Chronicles of the South Carolina Sea Islands*. Winston-Salem, NC: John F. Blair, 1998.
Sink, Alice E. *Hidden History of Hilton Head*. Charleston, SC: History Press, 2010.
Wooster, Lyman D. *Antebellum Plantations on Hilton Head Island*. Hilton Head Island, SC: Heritage Library Foundation, 2007.

# INDEX

Altstaetter, Bill and Gwen, 4, 118
Ames, David, 117
Anderson, Dorothy, 120
Baldwin, Isaac, 18
Ballantine, Ralph, 68, 78
Banks, Ben, 53
Banks, Joni, 53
Barkie, Jerry, 72
Baumberger, Martha, 59–61
Baylord, Richard, 121
Baynard, Ephraim, 21, 25
Baynard, William, 18, 21, 22
Beauregard, P.G.T., 26
Beine, Bob, 103
Bligen, Bill, 119
Blue Lady, 124
Brafman, Frank, 74
Brock-Carlyle, Karena, 99
Brost, Nancy, 53
Burke, Tim, David, and William, 55
Carota, Bobbe, 76
Carota, Buzz, 59, 76
Chapman, Frank, 72, 74, 75
Charles I of Spain, 10
Charles II of England, 16
Church of the Crazy Crab, 56
Ciehanski, Nancy Ann, 57, 58
Coastal Discovery Museum, 79
Condit, Russ, 59, 72, 108
Cornet, Fred O., 72
Cotton, Angus, 53, 54, 80
Cotton, Beverly, 53
Cross, Wilbur, 118
Curry, John and Valerie, 87, 92
Daly, Gloria, 83, 87
Davant, Charles, 18
Davis, Howard, 69
De Ayllon, Lucas, 10, 11
De Coligny, Gaspard, 12
DeLoach, Cartha "Deke," 116
deVere, Paul, 61
Dickinson, Emily, 36
Drayton, Thomas F., 26, 28, 29

Drayton, Percival, 28
Drayton, William, 28
Driessen, Henry, 24, 57, 59, 62, 72
Dunn, Jerry, 59
Du Pont, Samuel Francis, 27
Dye, Pete, 80
Edwards, Berry and Ruthie, 106
Edwards, Wayne, 71
Ferguson, Willie "Bill," 73, 74
Forbes, Steve, 58
Fraser, Charles, 1, 7, 47, 52, 65, 66, 68, 77, 78, 80, 95, 97, 109, 122
Fraser, Joe, 7, 54, 80, 94
Fraser, Gen. Joseph, 50
Gillmore, Quincy A., 31
Gullah culture, 23, 37, 40, 118
Greers, 7, 14, 88, 89, 91, 124
Hack, Billie, 115, 123
Hack, Fred, 50
Hack, Fred and Billie, 67
Harberger, Norman, 113
Hazelton, Henry, 57
Hefter, Natalie, 40, 102
Heinrich, Charlotte, 114
Heritage Classic, 7, 54, 80, 81, 96
Hickel, Walter, 98
Higginson, Thomas W., 36
Hilton, Capt. William, 14
Hilton Head Symphony, 83, 87
Howard, Rev. Thomas, 37
Hudson, Barbara, 45
Hudson, Benny, 45, 46
Hudson, J.B., 45
Hunter, Gen. David, 32, 33
Hurley, William and Sara, 42, 43
Jackson, Rev. A.W., 36
Johnson, Libby, 59
Jones, Buddy, 104
Jones, David, 98
Jones, Wes, 57
Keep, Kate, 74
Kenneweg, Karen, 56
Kenneweg, Peter, 56

King, Billie Jean, 95
King Neptune statue, 71
Kirk family, 18
Lamotte, Beryl, 53
Lamotte, Peter, 52, 53
Lanier, Sidney, 7
Larsen, Chuck, 56
Lauderdale, David, 54, 112
Laughlin, Drew, 24
Laurens, Henry, 12
Lee, Francis D., 26
Lee, Robert E., 34
Littel, Bill, 107
Loomis, Alfred, 41, 50
Marscher, Bill, 59, 101
Marscher, Fran, 101
Masteller, Bob, 122
Marsh Tacky horse, 40
Martinangel, Captain, 18
Martyr, Peter d'Anghiera, 11
Mauney, Miles and Ernest, 84
Mauney, Miles and Dorothy, 84
Mauney, Phyllis, 85
McConnell, Jack, 121
McKee, Henry, 38
Miller, Rev. John, 83
Miller, Johnny, 96
Mitchel, Ormsby, 31, 34, 35
Montgomery, James, 33
Moore, James, 104
Moultrie, William, 17
Nicklaus, Jack, 80
Old Fort Pub, 78
Onorato, Patricia, 124
Onorato, Robert, 70, 71, 124
Peeples, Tom, 72, 74, 79
Peeples, Tom and Mary Ann, 109
Perkins, Dorothy G., 74
Peterson, Don, 97
Pickett, Peggy, 20
Pinckney, Eliza, 20
Racusin, Ben, 57, 58
Ramsey, S. Paul, 72
Reilley, David, 56
Reilley, Diane, 56
Reilley, Tom, 56, 63, 64
Ribault, Jean, 12, 13
Richardson, James N. "JR," 110
Richardson, Lois and Norris, 51
Saussure, Louis de, 23
Senf, Tom, 113
Shay, Willis, 82, 86, 87, 90

Sherman, Gen. Thomas, 31
Simmons, Charlie, 44
Smalls, Robert, 38
Smith, Stan, 100
Stebbins, C.C., 67
Stevens, Gen. Isaac, 30
Stoney, "Saucy Jack," 21
Toomer family, 56
Tooms, Davis, 103
Tubman, Harriet, 33
Unterkoefler, Bishop Ernest, 56
West, John C., 93
Wilborn, Isaac, 123
Wiley, Phoebe Ruth, 62
Williams, Howard, 104
Witherspoon, John, 28
Wooster, Lyman, 21

AN IMPRINT OF ARCADIA PUBLISHING

Find more books like this at
**www.legendarylocals.com**

Discover more local and regional history books at
**www.arcadiapublishing.com**

Consistent with our mission to preserve history on a local level, this book was printed in South Carolina on American-made paper and manufactured entirely in the United States. Products carrying the accredited Forest Stewardship Council (FSC) label are printed on 100 percent FSC-certified paper.